Painting American
FOLK ART

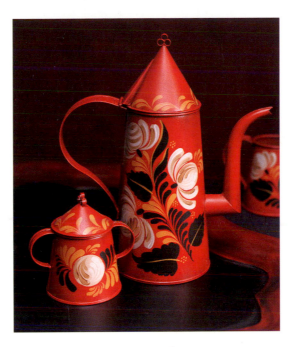

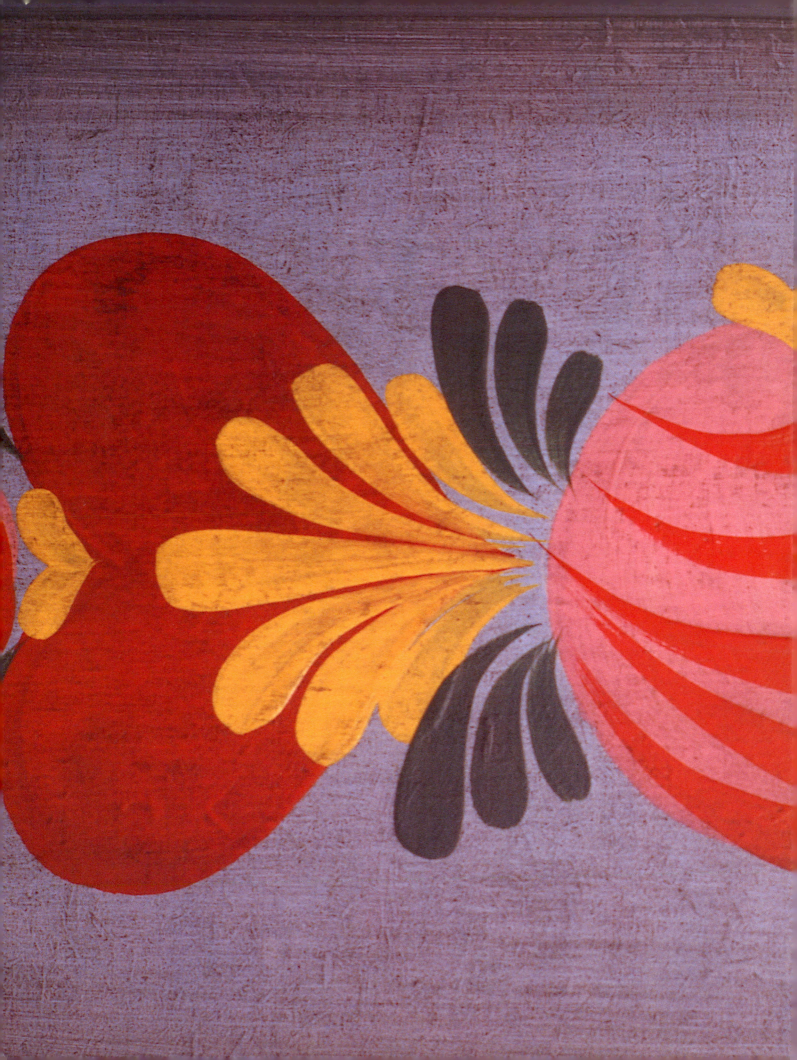

Painting American
FOLK ART

DECORATIVE
PAINTERS
LIBRARY

Andy B. Jones

WATSON-GUPTILL PUBLICATIONS/NEW YORK

Senior Editor: Candace Raney
Edited by Joy Aquilino
Designed by Areta Buk
Graphic production by Hector Campbell

First published in 2000 by Watson-Guptill Publications,
a division of BPI Communications, Inc.,
1515 Broadway, New York, N.Y. 10036

Library of Congress Cataloging-in-Publication Data
Jones, Andy.
 Painting American folk art / Andy B. Jones.
 p. cm.—(Decorative painters library)
 Includes index.
 ISBN 0-8230-1278-6
 1. Painting, American—Technique. 2. Painting—Technique. 3. Folk art—United
States—Technique. I. Title. II. Series.
 ND205 .J65 2000
 745.7'23'0973—dc21
 99-046330

Printed in Hong Kong

First printing, 2000

1 2 3 4 5 6 7 8 9 / 08 07 06 05 04 03 02 01 00

ACKNOWLEDGMENTS

Several people helped me create this book in a variety of ways. No matter how odd my requests were, they never turned me down! For their help and support I am grateful.

Priscilla Hauser

Ann Jones

Karen Milhous

Phillip C. Myer

Chris and Richard Williams

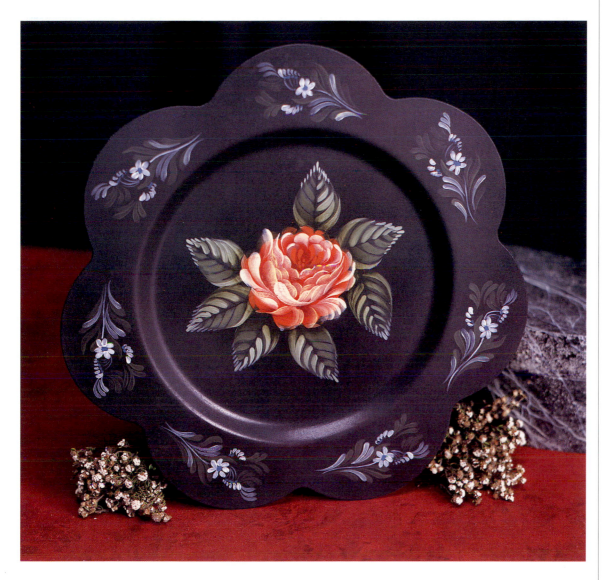

Contents

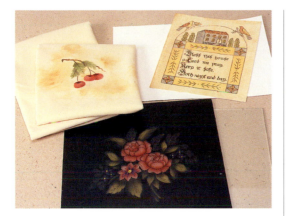

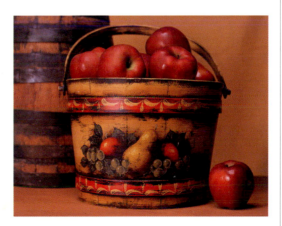

Introduction

Although the primary goal of this book is to recreate the decorative painting styles of American folk artists using today's art materials, modern decorative painters should also consider the work of their creative forebears within a historical context so that they can better understand and appreciate it. By simultaneously learning about the original techniques while adapting them to modern materials and tastes, we can establish a connection with the artists who have come before us, whose work not only survives but still speaks to us. American folk art may be rooted in the past, but our interest and participation in the forms of the past will ensure their continued growth.

The original practitioners of American folk art were the first European immigrants, whose folk art traditions were hundreds of years old. In many instances, these artists had only makeshift materials and tools with which to express their creativity, but their enthusiasm, cleverness, and imagination are evident even in the crudest examples of their work.

THE PENN-DUTCH INFLUENCE

The German immigrants who settled in Pennsylvania during the early 1700s in what is now Lancaster County are commonly known as the Pennsylvania Dutch (a mispronunciation of the word *Deutsch,* which means "German"). These energetic, resourceful people expressed their love of adornment in many ways. One example, the hex sign, has become a universal symbol of Penn-Dutch culture. The settlers believed that these highly decorative, usually geometric, designs could ward off evil spirits and protect the inhabitants of their houses and barns. The legacy of the hex sign is a rich visual vocabulary of motifs, including the distelfink, the heart, and the tulip, and today many people display hex signs as emblems of life's rewards: good luck, friendship, peace, strength, abundance, and love.

By contrast, Fraktur painting, another quintessentially Penn-Dutch art form, arose from more earthly concerns—the desire to document marriages, births, and deaths—although the technique was also used to grace homes with

This Fraktur painting features beautiful flowers and a lengthy inscription in an elegant hand. *Artwork from the Decorative Arts Collection, Wichita, Kansas. Used by permission.*

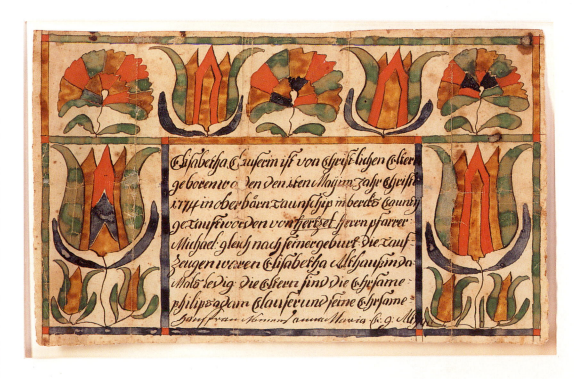

beautifully rendered blessings. The first Fraktur painters were typically clergymen and teachers who supplemented their incomes by producing these small paintings. Later, Fraktur painting was done almost exclusively by itinerant artists, who also painted dowry chests, document boxes, and other essential household items.

Wood graining—imitating the grain patterns of various species of wood with paint—was yet another specialty of the itinerant artists, who frequently grained the inexpensive wood frames in which their Fraktur paintings were hung. Many examples of graining from this period are not only primitive in technique but are vague representations, if not total exaggerations. The practice of painting one species of wood with a less-than-convincing version of another's grain pattern may seem peculiar, but the early American artists, most of whom were untrained, sincerely hoped to improve upon the native species. A skilled painter might even succeed in creating the illusion of an expensive exotic wood like mahogany or bird's-eye maple. The tools and mediums for graining varied, but the method was always the same: The paint—a curious mixture of stale beer or ale, vinegar, sugar, and powdered pigment—was applied to the surface, then immediately manipulated with any one of a startling variety of tools, including feathers, combs, corncobs, glazier's putty, even fingers. What the itinerants lacked in formal skill they more than compensated for in imagination, which can be seen in the astonishing variety of grain patterns they employed. Today, the ingenious work of the "Colonial grainers" is highly sought after by collectors.

THE TIN REVOLUTION

Painted tinware was one of the first original forms of American folk art. The first tinware that was painted in America was actually imported from England, as was its style of decoration, which was known as lace-edge painting. The term refers to the tin-plated iron trays with pierced or "lacy" edges that were produced during the mid-1700s in Pontypool, Wales, the center of painted tinware production in England at the time.

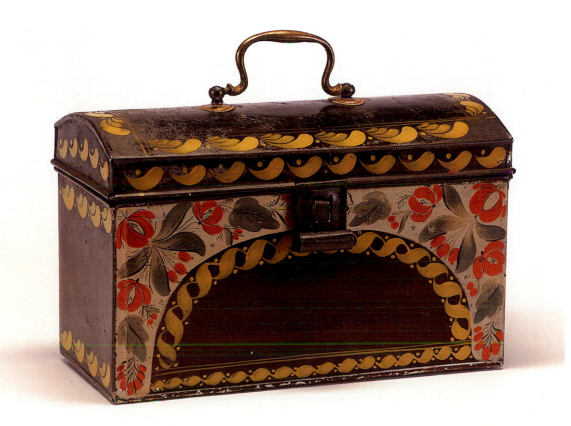

This masterfully painted document box is an excellent example of country tin painting. *Artwork from the Decorative Arts Collection, Wichita, Kansas. Used by permission.*

Introduction

American tinware was first produced in Berlin, Connecticut, sometime after 1740, by an Irish tinsmith named Edward Patterson, who in time taught his craft to many others. At first, the pieces were sold undecorated. For the Colonists, the fact that the items were made of tin was reason enough to purchase them, since most utilitarian goods were made of either pewter or iron. When tinsmiths began decorating their wares after the Revolutionary War, a truly American style of tin painting emerged: country tin painting. Actually, it was the tinsmiths' wives and daughters who undertook this task, which was then called "flowering," as the motifs were adapted from floral designs on English pottery. The pieces were rarely signed, so most of the artists remain unknown. One exception is Ann Butler, who sometimes signed her work, documenting her extraordinary brush control and sense of color and design.

STENCILS, VELVET, AND GLASS

As the 19th century progressed, the use of mass-production techniques in the creation of decorated items expanded. The European obsession with Chinese and Japanese decorative arts that began in the 17th century lasted well into the 19th. The bronzing technique was one of many Western attempts to imitate the various forms of metallic embellishment that adorned Asian lacquerware. American folk artists shrewdly simplified the task of creating delicately shaded forms by applying the finely ground metallic powders through stencils. In the United States, bronzed designs were applied to a variety of items, the most famous of which are the "Hitchcock chairs," which were produced by cabinetmaker Lambert Hitchcock in his Connecticut factory during the early 1800s.

Before the 19th century, decorative painting had been dominated by professionals—mainly men, some formally trained, most self-taught—who produced works that were designed to appeal to a mass audience, either by featuring universally appealing motifs and palettes or by imitating complex and expensive techniques and materials. The new group was exclusively female, comprising women who had the wealth and leisure to pursue a variety of "feminine" pastimes, including decorative painting. The art

A bronzed tray comprising freehand as well as stenciled motifs. *Artwork from the Decorative Arts Collection, Wichita, Kansas. Used by permission.*

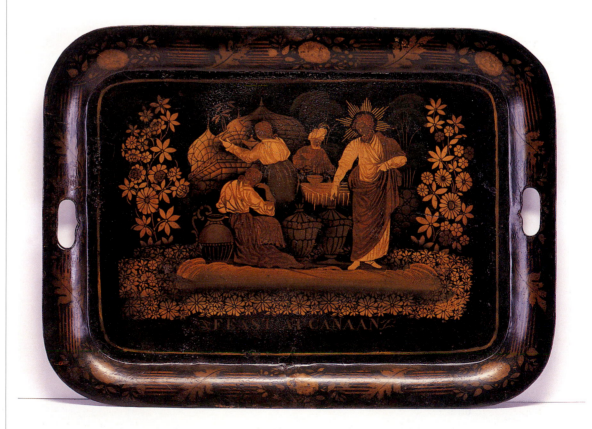

of theorem painting—stenciling multicolored images on cotton velvet—arose during the early 19th century as an element of finishing school curricula, providing young female students with a welcome departure from the rigors of needlework and penmanship. The origins of the term "theorem painting" are uncertain, and may be derived from the method of deduction used in mathematics and logic, though in this case the "problem" that needs to be "solved" is how to create an ostensibly seamless image using multiple stencils.

Some of the most fascinating and beautiful pieces of American folk art painting were done on glass—specifically, on the backs of sheets of glass. Tinsel painting, which was also referred to as reverse-glass painting, pearl painting, and oriental painting, reached the height of its popularity during the 1850s. Few antique tinsel paintings survive because the glass, in addition to being fragile, was a less than ideal support for paint. Though many examples are rather crude, the luminous compositions leave viewers at a loss as to how they were created, since they appear seamless when seen from the front. Tinsel painting isn't a significant form of American folk art, but it is one of the loveliest.

THE TWO PETERS

A definitive assessment of 20th-century decorative painting has yet to be written, but the period already has two outstanding practitioners. Their lives were similar in some superficial ways: Both were named Peter, both lived and worked in the northeast, and both were active during roughly the same period. Their work, however, was very different.

Peter Hunt lived in Provincetown, Massachusetts, which is located at the very tip of Cape Cod, from the 1930s through the early 1960s. The owner of an antique shop, Hunt also refurbished old, discarded pieces of furniture and other items—often sawing parts off one piece and attaching them to another—repainting them with what he described as "peasant designs that are the gayest and happiest form of decoration." The primary element of his compositions was the simple comma stroke, which he used in countless configurations. His cheerful, expressive style, which displayed an unusual sense of design and a bold, vivid palette, became widely sought after, and as its popularity grew he gradually stopped

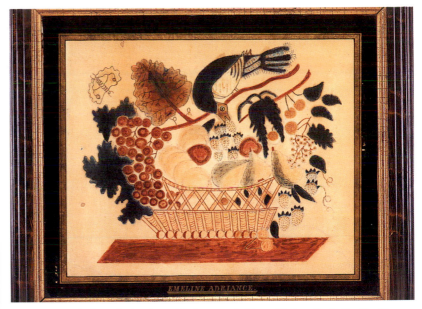

A theorem painting of a basket of fruit attended by a bird and a butterfly. The lack of perspective (note shape of the tabletop) and the inconsistencies of scale enhance its charm. *Artwork from the Decorative Arts Collection, Wichita, Kansas. Used by permission.*

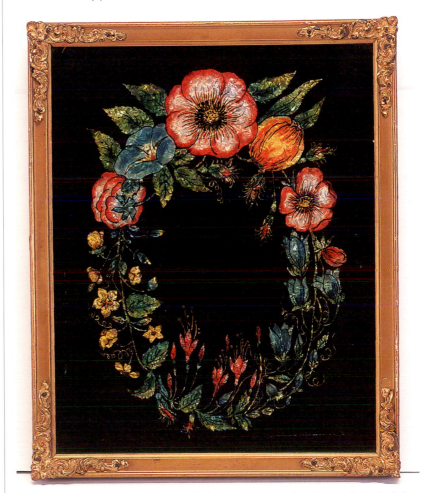

The dazzling palette of this tinsel painting accentuates the gleam of the tin foil beneath it. *Artwork from the Decorative Arts Collection, Wichita, Kansas. Used by permission.*

Introduction

selling antiques and devoted himself to creating his one-of-a-kind pieces. Still in high demand among collectors, his work is truly a joy to behold.

Peter Ompir—the "other" Peter—was a decorative artist who lived and worked in New England from the 1930s through his death in 1979. He had studied painting at the Art Institute of Chicago but was unable to find patrons for his work as a fine artist during the Depression, so he began decorating antiques and ordinary household items with a charming style of folk painting. Ompir had an uncanny ability to visually merge a design with the object on which it was painted. The complex painting techniques that

he favored, which included a heavy, mellow antiquing glaze, yielded subtle, sophisticated results. This quintessentially 20th-century artist, an inventive and imaginative survivor, deserves an entry in the annals of American folk art for the creativity of his work, which will forever make an impact on those who see it.

THE DECORATIVE PAINTERS LIBRARY

The books in the Decorative Painters Library are designed to fulfill two goals. The first is to instruct beginning painters in the fundamentals of the craft. This essential information, which is covered in depth over three chapters, is then

The merry man on horseback, the miniature village, and the "meadow" of brushstroke hearts and flowers epitomize Peter Hunt's fanciful style.

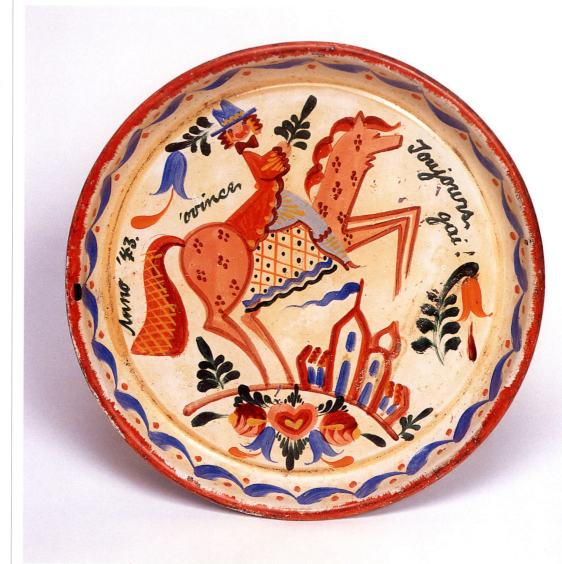

applied to achieve the second goal of the series: to give readers the means to create inspiring projects that feature patterns in a specific subject area. The instructions can be followed exactly as they appear, or adapted to accommodate the artist's personal tastes. A painter can choose a project that corresponds to his or her skill and confidence level by noting the "degree of difficulty" rating:

 EASY

MODERATE

CHALLENGING

Whatever your interests and goals as an artist, I hope that this book encourages you to pursue your creative development. If your energies are focused on decorative painting, I urge you to join the Society of Decorative Painters, an international organization with hundreds of chapters across the United States. For more information, contact them at the following address:

SOCIETY OF DECORATIVE PAINTERS
393 North McLean Boulevard
Wichita, Kansas 67203-5968
(316) 269-9300
http://www.decorativepainters.com/

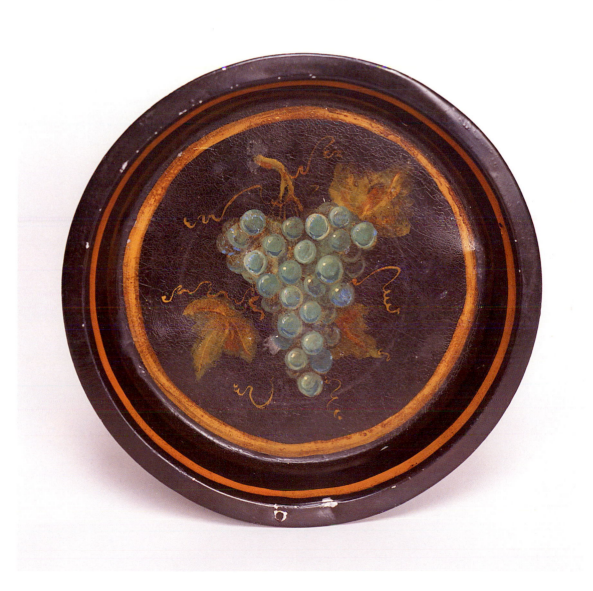

A tin pie plate painted by Peter Ompir. A black background is somewhat unusual for Ompir; the light ocher background shown in the project on pages 92–95 is actually more typical of his style.

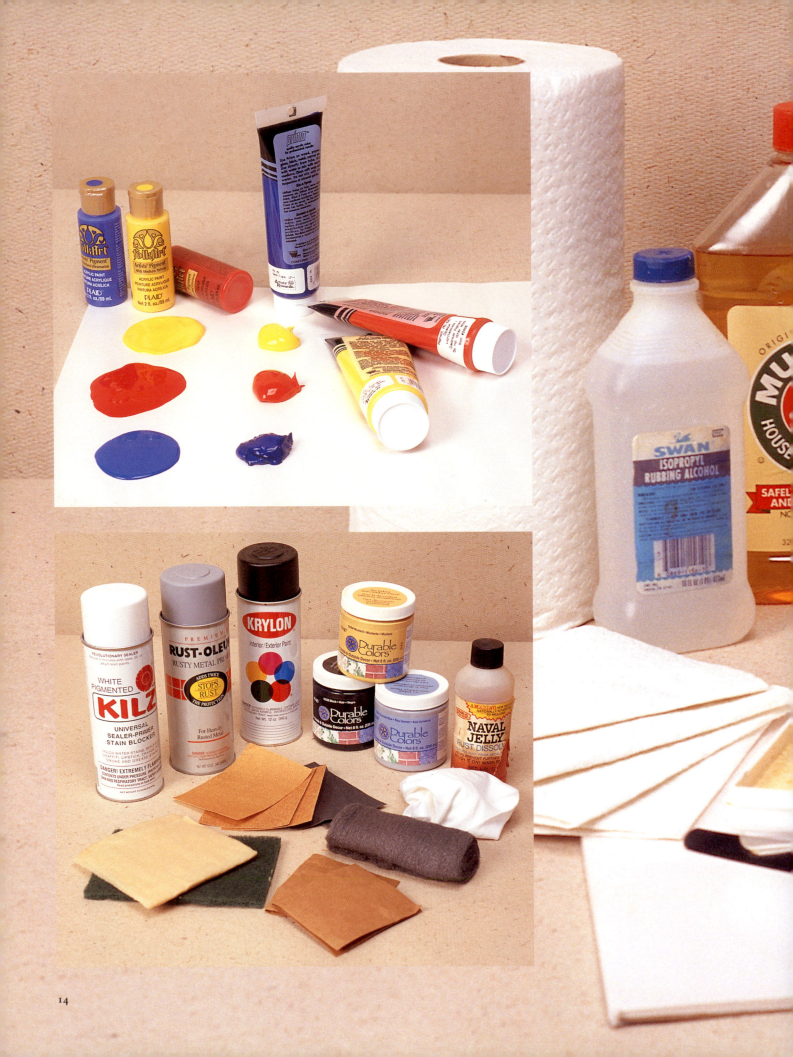

1 Your Painting Supplies

Working with Acrylic Paints

Originally introduced to the fine-art and crafts markets during the 1950s, acrylic paints quickly gained popularity because of their bright, rich coloration, quick drying time, and ease of clean up. Almost all of the painting techniques demonstrated in this book were originally done with oil paints, or with a type of modified oil-based paint called japan paint. I learned to paint with oil paints, then began using acrylics when they became popular, and today I use acrylic paints for most of my decorative painting projects. Recent advances in paint technology have made it possible to recreate the look of the old techniques with acrylic paints, making the process much easier.

Acrylic paints come in two varieties: *craft acrylics* and *artists' acrylics*. The colors of craft acrylics, which are labeled with descriptive color names like "barn red," are often created by mixing several pigments. Because the labels on these paints don't usually indicate which pigments were used to make a color, many times mixing two colors together can yield an unpleasant or unexpected result. Despite these limitations, using craft acrylics straight out of the bottle is fine for many applications, such as basecoating a project prior to painting a design. For painting designs, though, I prefer to use artists' acrylics. Sold in tubes or in 2-ounce plastic bottles, artists' acrylics contain pure pigments, and each

color is usually identified by the name of the pigment that was actually used to impart color to the paint, such as burnt umber or naphthol crimson. This information is particularly important when mixing colors, since you always know which pigments you're using as well as the result you're likely to get.

WORKING PROPERTIES

Acrylic paints consist of pigments suspended in a polymer emulsion (a mixture of an acrylic resin binder and water). They dry in only 15 to 30 minutes; once dry, the paint film is waterproof. Acrylics allow an artist to execute a step, then let it dry completely (with no chance of smearing) before proceeding to the next.

The most important reason for knowing about a paint's *working time*—the amount of time that you have to work with it before it begins to dry—is that it determines which methods you can use to blend colors during the painting process. When they're used straight from the bottle or tube, acrylics dry too rapidly to be applied one at a time and blended on the painting surface; if you attempt to do this you'll be fighting a losing battle with the intrinsic character of the paint. Instead, you must use techniques that take advantage of their rapid drying time. For example, you can use the *drybrush* technique (see page 33), in which one thin layer of color is applied over another layer as soon as it is completely dry, so that the colors are blended *optically;* that is, two translucent layers of color combine in the viewer's eye to create a third. You can also blend colors on the brush, then apply the already blended color to the surface and leave it alone to dry. (See "Sideloading" and "Doubleloading," pages 34 and 35.)

It is possible to modify acrylic paints by adding *mediums,* which are compatible substances that change the paints' characteristics. Sometimes a medium is added so that the paint can be used on a surface that isn't normally receptive to paint, like glass or certain kinds of fabric. In this book, mediums are used primarily to extend the paint's working time and to make it beautifully translucent. For more information, see "Acrylic Mediums," page 20.

Shown here are the two types of artists' acrylic paints. Squeeze-bottle acrylics *(left)* have a fluid consistency, while tube acrylics *(right)* are more gel-like.

BUYING PAINTS

When you shop for paints, you don't need to buy every single color that's on the shelf or even in a specific product line. You can either use the materials list that accompanies each project as a shopping list, or you can learn to mix virtually any color using just a few bottles of paint. (See "Choosing and Using Color," page 30.) Below is a complete list of colors that were used to paint the patterns in this book. (In some instances, it may be necessary to purchase or mix the colors that are specified for basecoating.) I use FolkArt Artists' Pigments, which are manufactured by Plaid Enterprises and packaged in 2-ounce squeeze bottles. These paints are available at most art supply and craft stores.

PROJECTS PALETTE FOR *PAINTING AMERICAN FOLK ART*

TITANIUM WHITE	PURE ORANGE	ALIZARIN CRIMSON	SAP GREEN
WARM WHITE	RED LIGHT	TRUE BURGUNDY	HAUSER GREEN LIGHT
YELLOW LIGHT	NAPHTHOL CRIMSON	BURNT CARMINE	HAUSER GREEN MEDIUM
MEDIUM YELLOW	ASPHALTUM	BRILLIANT ULTRAMARINE	GREEN UMBER
TURNER'S YELLOW	BURNT SIENNA	DIOXAZINE PURPLE	PAYNE'S GRAY
YELLOW OCHER	BURNT UMBER	PRUSSIAN BLUE	PURE BLACK
RAW SIENNA			

Selecting Your Brushes

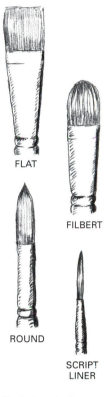

FLAT

FILBERT

ROUND

SCRIPT
LINER

Basic brush shapes.

Without a doubt, brushes are your most important decorative painting tools. You should always use the best brushes that you can afford, as only good-quality brushes will allow you to achieve satisfactory results. Brushes of inferior quality will frustrate you because they won't perform properly. I find that my students' painting problems are often caused by inferior brushes, or by brushes that have been ruined by neglect. If you start with good-quality brushes and maintain them properly, they will perform well for many years.

BRUSH BASICS

HAIRS The word "hairs" is commonly used to refer to the part of the brush that holds and applies paint, though brushes can be made of animal hairs such as sable, squirrel, badger, and boar; synthetic fibers like nylon or polyester; or a combination of the two.

SHAPES The part of the brush in which the hairs are arranged is called a *ferrule*. Ordinarily made of metal, the ferrule also attaches the hairs to the handle. As explained below, the shape of the ferrule determines the shape of the hairs. The basic shapes of brushes used for decorative painting are flat, round, bright, and filbert. As the name suggests, the hairs of *flat* brushes are held in a flattened ferrule, and are all very close to the same length. *Brights* also have same-length hairs, but the hairs are shorter than regular flats. The hairs of *round* brushes are arranged in a cylindrical ferrule and taper to a soft point. *Liners* are small round brushes whose hairs taper to an extremely fine point. *Filberts* are also rounded at the end, but the hairs are held in a flat ferrule.

SIZES The sizes of most of the brushes you'll use for decorative painting are listed in catalogs by number—from 10/0 (the smallest) to 24. A size 2, for example, is about $1/8$ inch; a size 10 is $3/8$ inch. Sizes for larger brushes are often given in inches.

As you gather together a collection of brushes, buy every other size within a category, then fill in as needed. Of course, if you're going to paint primarily small things, purchase the smaller brushes first. If you're painting large things, don't forget to get a small brush for detail work.

DECORATIVE PAINTING BRUSH KIT

In addition to serving as an all-around basic decorative painting brush kit, the assortment of brushes listed below is used to create the American folk art projects in this book.

I use brushes manufactured by Silver Brush Limited for my decorative painting. Their brushes are superior in quality and available nationwide. Their Ruby Satin line is made with nylon hairs only, and their Golden Natural series is manufactured with a blend of synthetic filaments and animal hairs. I use the mixed-hair brushes for most of my work. The properties of the natural hair allow the brush to hold moisture and release it evenly, while the synthetic hair gives the brush "spring," or resiliency. Try several of each kind of brush to determine which work best for you.

- *Flats.* Golden Natural Series 2002S, nos. 8, 10, and 12. I use flat brushes for the majority of my decorative painting work because they are so versatile.
- *Round.* Golden Natural Series 2000S, no. 4. The round brush is necessary for creating beautiful brushstrokes, especially large comma strokes. Select a brush with a fine point and a full "belly," or midsection, and make sure there are no stray hairs protruding from the ferrule. You'll have to "break in" your new brush over three or four painting sessions before it will become more responsive to your hand.
- *Script liner.* Golden Natural Series 2007S, no. 2. Liners come in several different hair lengths; for example, spotters have very short hairs, and script liner, or scroll, brushes have very long hairs. Script liners are designed to hold a lot of paint. When you use a liner brush with short hairs you will find yourself constantly having to refill the brush. This particular script liner, or scroll, brush can be used for most fine detail work. It has very long hairs and is designed to hold a great deal of paint. If you practice using this versatile brush, you will quickly become comfortable with the long hairs and appreciate its responsiveness.
- *Filbert.* Ruby Satin Series 2503S, no. 8. A filbert is useful for highlighting. Because its

hairs have rounded corners, it doesn't leave conspicuous marks that are sometimes left by flat brushes.

- *Wash brush.* Golden Natural Series 2008S, $^3/_4$ inch. This large flat brush is very useful for applying basecoats (see page 41) and for any decorative painting application where large areas must be covered with paint.
- *Stencil brushes.* Golden Natural Series 1821S, nos. 8 and 14. The hairs of these stencil brushes, which are made from the highest quality hog bristle, are set in a round ferrule and are all the same length. Use this brush by holding its handle upright and sparsely loading only the flat surface of the hairs. Never use a stencil brush if it's wet.
- *Mop brush.* Golden Natural Series C9090S, $^3/_4$ inch. This very soft brush, made from top-quality goat hair, is designed for very lightly blending and softening paints or glazes, and for softening background antiquing. It should *never* be used for paint application.
- *Glaze/varnish brushes.* Series 9094S, 1 and 2 inch. These sturdy brushes are far superior to a foam brush for the application of varnish in that they are much less likely to form air bubbles on the project surface. They can also be used to prime and basecoat small and medium-sized projects.

BRUSH CARE AND MAINTENANCE

The correct procedure for cleaning a brush must be mastered from the beginning, and your brushes must be cleaned after every painting session. Brushes will quickly be ruined if you allow paint to dry or harden in the bristles. No matter how skillful a painter you are, your work will suffer if you mistreat your brushes. With proper care and cleaning your brushes will perform as they were designed to, and should last for years.

Rinse dirty brushes in cool, running water, working the bristles gently against the palm of your hand. As you rinse the brushes, add a small amount of brush cleaner or conditioner, or a mild vegetable oil soap such as Murphy Oil Soap. Continue working the brush in your palm until no more color is released from the brush. Store the brushes in a glass or jar, bristle end up, with nothing pressing on or bending the bristles.

Acrylic paint that has been allowed to dry in a brush can sometimes be removed by cleaning the brush in rubbing alcohol, which acts as a solvent, "melting" the paint so that you can loosen it from the hairs of the brush. Once you've loosened the paint, clean the brush with water and soap as described above. Alcohol is hard on brushes, so use this cleaning method only when absolutely necessary. The best strategy is to never allow paint to dry in your brush!

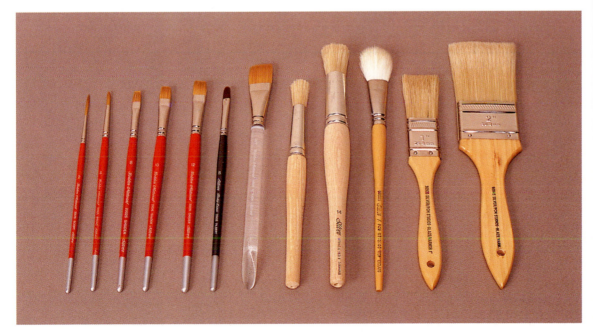

The brushes you'll need to create the projects in this book *(from left to right):* a no. 2 script liner; a no. 4 round; three flats, nos. 8, 10, and 12; a no. 8 filbert; a $^3/_4$-inch wash brush; two stencil brushes; a $^3/_4$-inch mop brush; and 1- and 2-inch glaze/varnish brushes.

Decorative Painting Necessities

In addition to your paints and brushes, you'll need a variety of supplies in order to create the projects in this book.

BASIC PAINTING SUPPLIES

PALETTES Acrylic painters need two palettes. For mixing color and loading your brushes, you'll need a wax-coated disposable paper palette designed for use with water media. (If you use a palette designed for oil painting, the surface will wrinkle and buckle and make it difficult to paint.) This type of palette is very convenient: Just tear off the used sheet and throw it away at the end of a painting session, or when the sheet is completely covered with paint. Purchase the largest size you can find so that you can use a single sheet for more than one session.

You'll also need a covered palette that will keep your acrylic paints moist. A good choice is the Sta-Wet Palette made by Masterson Industries. For a detailed description on how to set up your palettes, see "Getting Started," page 26.

PALETTE KNIFE You'll need a palette knife for mixing paints. Invest in a good-quality one with a long, flexible blade. If you purchase a good palette knife, you'll only have to make the purchase once. Don't buy a plastic palette knife or one with a stiff blade or you won't be able to "feel" the consistency of the paint as you mix it.

WATER CONTAINER You'll need a container of water for rinsing brushes during your painting sessions. You can purchase a container designed for this purpose, or use any sturdy, wide-mouth container that won't tip over easily. The container shown in the photograph below, left, has special slots designed to hold brushes and a ribbed area in the bottom of the well to help remove paint from the hairs.

PAPER TOWELS Always use high-quality paper towels that are soft as well as absorbent. You'll be wiping and blotting your brushes on paper towels often while you work, and rough, coarse ones can cause the hairs to curl or separate.

SOAP FOR CLEANING BRUSHES Use a commercial brush cleaner or a mild vegetable oil soap to clean dirty brushes without leaving any residue. Both can also be used to clean dirty hands.

RUBBING ALCOHOL Alcohol can be used to clean residue of dried paint from your brushes. You should always try to remove all the paint from a brush before it has a chance to dry, but if some paint does dry in the brush, dip it into alcohol, then work the hairs in the palm of your hand before cleaning it as described on page 19.

ACRYLIC MEDIUMS

There are four mediums formulated especially for use with acrylic paints that are required to complete the projects in this book. These mediums not only make the paints easier to work with, but they also yield some beautiful translucent effects. I use FolkArt acrylic mediums, which are made by Plaid Enterprises.

BLENDING GEL This revolutionary product, which is also called gel retarder, extends working time without thinning the paint's consistency—in other words, without making it watery—an important consideration for blending applications.

Basic painting supplies: paper towels, rubbing alcohol, brush conditioner and Murphy Oil Soap (for cleaning brushes), water container, palette knife, and Sta-Wet and disposable paper palettes.

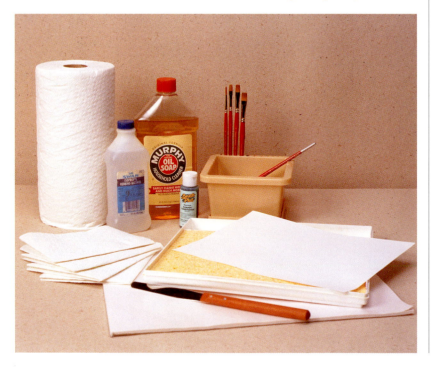

GLAZING MEDIUM In addition to extending the working time of acrylic paint, this product also makes it beautifully translucent. In this book, Glazing Medium is used to create glazes for antiquing (see page 43) and graining (page 52).

GLASS AND TILE MEDIUM When acrylic paint is applied to slick surfaces like glass and glazed ceramic, it beads up, making it impossible to manipulate with a brush; once dry, it can be easily scratched or rubbed off. A coat of this medium gives slick surfaces "tooth," and even allows the paint to be applied in thin translucent washes, like those used in tinsel painting (see page 76). Glass and tile medium can also be used with ink.

TEXTILE MEDIUM Acrylic paint applied to fabric will dry to an extremely stiff finish and is unlikely to withstand laundering. When combined with textile medium, acrylic paints dry to a soft, translucent sheen and are colorfast. In this book, textile medium is an essential ingredient in the theorem painting project (see page 80), in which it is used to impart a translucent quality to the paint, allowing the white of the fabric ground to show through as highlights and creating soft, subtle shading.

SURFACE PREP SUPPLIES

Before you can actually begin painting a design, you'll need to prepare the surface of your project. The following are some standard supplies for preparing wood and metal surfaces.

SANDPAPER Sandpaper is available in hardware stores and home improvement centers. You'll need two grades: medium (#220-grit) for the initial rough sanding, and fine (#400-grit) for smoothing and finishing. Buy a package of each so you have them on hand.

TACK RAG OR CLOTH A tack rag is a piece of cheesecloth that has been treated with resin and varnish. Its extremely sticky surface is used to remove sanding residue, giving finished pieces a smoother, more professional look.

SCRUB PAD Use a scrub pad to "sand" a primed wooden surface prior to basecoating or to remove grime from metalware.

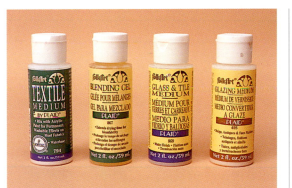

Acrylic mediums: textile medium, Blending Gel (referred to generically as gel retarder), glass and tile medium, and Glazing Medium.

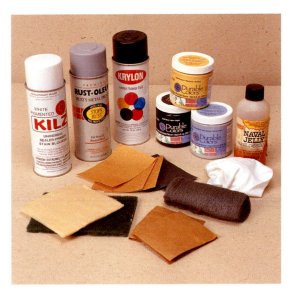

Surface prep supplies: primers for wood and metal, spray paint and Durable Colors acrylic paints for basecoating, Naval Jelly, sandpapers in several grits, cotton rags, very fine steel wool, a tack rag, a scrub pad, and pieces of a brown paper bag.

NAVAL JELLY Naval Jelly removes rust from metal. Use it on metal objects that have accumulated grime or show any signs of rust. Carefully follow the manufacturer's directions and wear rubber gloves when using it.

PRIMER Primer is required for metalware as well as for some wooden pieces. If your wooden pieces are small, you can use a spray primer. For metal objects, use a spray-on, flat-finish gray primer specially formulated to inhibit rust and provide a reliable surface for paint.

BASECOAT PAINT To impart color to the surface, you can use craft or artists' acrylics or latex house paints. I enjoy using Durable Colors by Plaid, acrylic paints that are specially formulated to deliver excellent wearing strength. They are available in a wide range of colors, are semigloss in sheen, and can be cleaned up with soap and water.

Decorative Painting Necessities

BROWN PAPER BAG An unprinted brown paper bag (like the ones at your local grocery store) can be used to smooth a final coat of basepaint or an interim coat of varnish.

COTTON RAGS Lint-free cotton rags, like those made from old T-shirts, are indispensible for wiping off antiquing glazes or stains.

STEEL WOOL In this book, a very fine grade of steel wool (#0000) is used in a special antiquing technique (see page 95). If you use a coarser grade, chances are you'll ruin your piece.

VARNISH I varnish all of my decorative painting projects with a good-quality water-based polyurethane. For small projects I like FolkArt Artists' Varnish, which is sold at many art supply and craft stores. If you plan to varnish many pieces, you can buy gallon-size cans of Varathane at home improvement stores. These two brands are available in a range of sheens, from matte to high-gloss.

TRACING AND TRANSFERRING SUPPLIES

Once your surface is properly prepped and ready for decorative painting, you'll need to trace a pattern and transfer it to the surface. (See "Tracing, Sizing, and Transferring Patterns," pages 44–45, for detailed instructions.)

STYLUS Similar in shape to a pen, a stylus is used to trace the lines of a pattern in order to transfer them to a project's surface. Unlike a pencil, a fine-point stylus produces a consistent fine line, so use one whenever you transfer a pattern.

TRACING PAPER This transparent paper is specifically designed for tracing. Do not attempt to substitute tracing paper with tissue paper, which is not sturdy enough. Tracing paper can be purchased in art and craft stores and is sold in several sizes. Buy at least a medium-sized package to avoid having to piece several smaller sheets together.

FINE-TIP BLACK MARKER Use a fine-tip marker to trace patterns onto tracing paper. Choose one that contains permanent ink so your tracings won't smear.

TRANSFER PAPER This special paper, which is designed for transferring decorative painting patterns to surfaces, will wash off with water. Do *not* use graphite or typewriter carbon paper, which will cause unsightly messes. Use white transfer paper on dark- to medium-value surfaces and gray transfer paper on light- to medium-value surfaces.

CHALK Purchase a box of ordinary blackboard chalk to transfer simple strokework designs. Do not buy dustless chalk or sewing or tailor's chalk—neither will work—and avoid colored chalk because its pigment might bleed through or otherwise affect the color of your paint.

PENCIL A pencil is invaluable for making marks that will need to be erased, such as the center point of a surface. Do not use a pencil to transfer patterns because it will make increasingly wide lines as its point dulls with use.

TAPE Use Scotch or painter's tape to keep tracings and transfer paper in place.

Tracing and transferring supplies: A large pad of tracing paper, chalk, transfer paper in white and gray, a stylus, a fine-tip black marker, and a pencil.

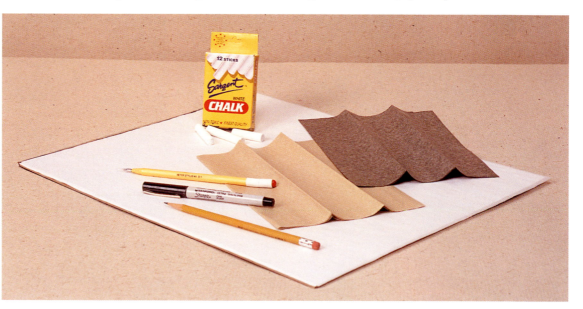

SPECIAL PROJECT SUPPLIES

Some of the projects in this book require special supplies. Before making any purchases, carefully read the project's instructions and materials list to see exactly what you'll need.

GLASS A glass surface is essential for cutting stencils, which requires a rigid surface that is resistant to heat and can't be cut with a knife. You can get a piece of window glass at a glass store or a home improvement center.

WHITE DRAWING PAPER This is helpful when working on stencils or painting on glass. Place the glass over the paper, slip the pattern between them, then either cut the stencil or paint the design.

ACETATE OR MYLAR These forms of plastic, which are sold in sheets at art supply and craft stores, are used to make stencils. Be sure to use sheets that are at least 0.3mm thick, as thinner sheets are likely to tear during stenciling.

STENCIL BURNER A stencil burner has a fine metal tip that heats to a high temperature and can be used to cut through acetate or Mylar. Stencils can also be cut with a craft knife, but a stencil burner is easier to handle—it's more like drawing with a pen—and much faster.

CROW QUILL OR DIP PEN This simple pen consists of a handle and a nib. Before using it, gently burn the tip of the nib in a flame to remove the oily protective coating. You'll need a bit of practice before you'll feel comfortable using one. A dip pen has a tendency to drip or spatter no matter how much experience you have with it, so always "warm up" by testing it out on a piece of scrap paper before working on your project.

WATERPROOF INDIA INK I use a mixture of brown and black inks to achieve a partially faded look that lends authenticity to my historical recreations. Be sure to use waterproof ink or it will bleed and run when you apply acrylic paint over it.

NONDRYING PLASTIC MODELING CLAY This is used to manipulate the glaze in the Colonial graining project (see page 52). Glazier's putty was originally used for this purpose, but modeling clay is a better choice because it won't dry out. It doesn't matter what color you use. A small package will last indefinitely.

RULING PEN A ruling pen is a professional draftsman's tool that is used to produce fine lines. To load the pen, first load a flat brush with thinned paint, then scrape the brush across the pen's slotted opening. Draw a straight line by running the pen's point along the edge of a cork-backed metal ruler. You'll need to practice in order to become proficient with this tool.

CORK-BACKED METAL RULER In addition to serving as a straightedge for a ruling pen, a cork-backed ruler can be used to measure surfaces to ensure the proper placement of designs.

TREASURE GOLD METALLIC WAXES Treasure Gold is a line of metallic waxes that serves as a safe substitute for bronzing powders (see "Bronzing," page 84). These waxes are available in many different colors and can be purchased at most art supply and craft stores.

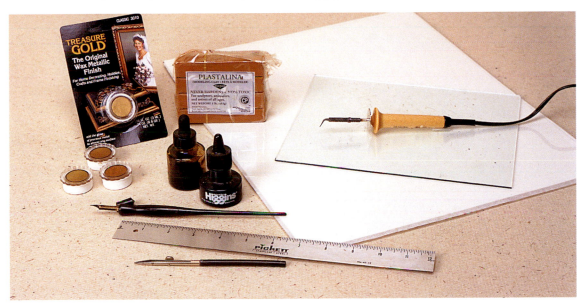

Special project supplies: Treasure Gold metallic waxes, plastic modeling clay, a large pad of white drawing paper, a piece of glass, a stencil burner, waterproof India inks in brown and black, a dip pen, a cork-backed ruler, and a ruling pen.

2 Decorative Painting Basics

Getting Started

After you've gathered together the necessary supplies, the next step is to organize your palettes so that you can begin learning how to handle your paints and brushes.

SETTING UP

Over the years, I've developed a routine of working with two palettes: I store my paints in a Sta-Wet palette to keep them moist and workable, and I mix colors and load my brushes on a disposable paper palette. This may sound a bit complicated, but it really fits my working style. If you try my method, I think that the process of painting will be easier for you, which in turn will make you more likely to succeed.

To prepare the Sta-Wet palette for painting, immerse the special palette paper in water. It's best to soak the paper overnight, because if you don't soak it long enough it won't keep the paints moist. Once the paper has been soaked, wet the sponge thoroughly, place it in the plastic tray, then lay the special paper over the wet sponge. Blot the palette paper with a piece of paper towel to remove any standing water, and it's ready for your paints. The palette should remain moist for several hours, although you may need to mist it with water occasionally.

When the palette is covered, the paint can remain usable for days or even weeks. I almost never load my brush or mix colors on the wet palette because I want to keep the colors I store there clean and pure. When I'm ready to paint, I take the cover off the wet palette, use my palette knife to move some paint to a clean area of my disposable paper palette, then either load my brush or mix my new color with the knife.

THE "RIGHT" CONSISTENCY

The term *consistency* refers to how thick or thin the paint needs to be for a particular painting technique. For most of the techniques that are used in this book, you'll be able to use your paint straight from the bottle or tube, which has a thick, creamy consistency.

To do brushstroke work—the "Essential Brushstrokes" that are shown on pages 27–29—you'll need to thin the paint by adding a little water to it and mixing them together with a palette knife. While you're mixing, keep the paint from spreading all over the palette by continually pushing it into a single mass. The consistency should be loose: When you pick up some paint on the palette knife, it should slide and drip off the knife with ease. To do linework, which involves creating fine, detailed lines (see page 29), the paint will need to be even thinner—the consistency of thin soup—but not so thin that it hardly contains any color. You don't want to paint your projects with "dirty water"!

Learning to create different paint consistencies requires some patience and practice. The only way to become skilled at handling paints is to actually sit down and begin painting.

LOADING A BRUSH

Stroke the brush into the paint, then apply pressure as you pull some paint away from the puddle, which will cause the hairs to spread. When you release pressure, the hairs will draw together, pulling paint into the brush. Repeat this procedure several times on both sides of the brush until its hairs are completely filled with paint.

I use my palette knife to move paint from my wet palette to my paper palette for mixing colors and loading brushes. To keep the paints on my wet palette clean, I wipe the knife on a paper towel before picking up a new color.

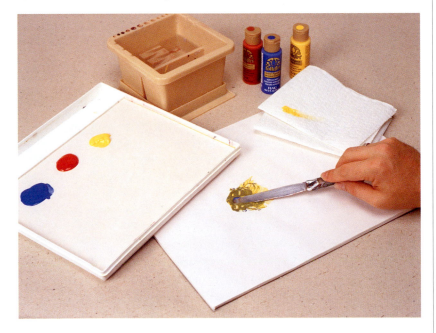

Essential Brushstrokes

Mastering the brushstrokes shown at right and on the following pages will help you learn to handle your brushes and paints competently—an accomplishment that is essential to your painting success. Most traditional American folk art painting techniques require exceptional brush control, a fact that is evident in the work of its original practitioners. With practice, you too can master these fundamental skills, but don't let the thought of having to practice lead you to consider skipping this section. If you can't control your brushes, your painting experience will be filled with frustration. Although you won't need to master all of these brushstrokes in order to complete a specific project, giving each one a try can only increase your skill and give you confidence, which in turn will make your painting experience more enjoyable.

COMMA STROKE

This quintessential brushstroke is the foundation of all the strokework you'll need to master. Using basically the same technique, a comma stroke can be painted with either a flat brush or a round brush. Decorative painters should know how to paint both, which require a fluid motion and considerable practice in order to achieve a graceful-looking result.

FLAT BRUSH COMMA STROKE Before you begin, thin the paint with water until it flows effortlessly from the brush (see "The 'Right' Consistency" on the opposite page).

1 Angle the brush toward the corner of your surface, gently touch its hairs to it, then immediately apply pressure. The ferrule (the piece of metal that attaches the hairs to the brush) should *almost* touch the surface.

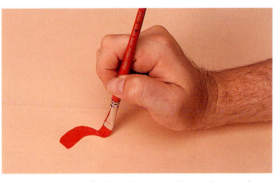

2 As you pull the brush hairs along the surface, gradually release the pressure . . .

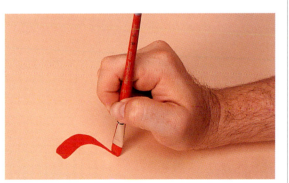

3 . . . while lifting the brush back to its chisel edge. This single, continuous motion will form the brushstroke. Do *not* turn or twist the brush. The brush will make the stroke simply by applying and releasing pressure while dragging it. If you're having trouble, attach a small piece of masking tape to the end of your brush handle. When you paint the stroke, the tape should *not* move—if it does, you're turning the brush.

Essential Brushstrokes

ROUND BRUSH COMMA STROKE To paint a comma stroke with a round brush, load the brush with loose-consistency paint (see "The 'Right' Consistency," page 26). Don't twirl the brush to a fine point after loading it; if the brush is too pointy, it will be difficult to make a nicely shaped head on the stroke.

I Angle the tip of the brush toward the corner of your surface. Touch the brush to the surface and apply pressure to it. The hairs will spread out, forming a nice rounded curve.

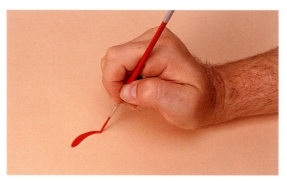

2 Gradually lift the brush as you drag it toward yourself, which will cause the hairs to spring back . . .

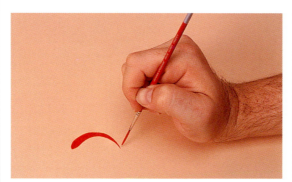

3 . . . and slowly taper to a fine line. You don't need to twist or turn the brush in order to do this. The release of pressure will cause the hairs to form the rest of the stroke.

S STROKE

This stroke is one of the most graceful in the decorative painter's repertoire. It's similar to the comma stroke in that it requires a single, continuous motion with a gradual application and release of pressure. You should learn to paint both left- and right-facing S strokes.

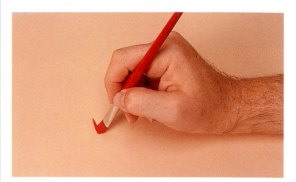

I Angle a loaded flat brush toward the corner of your surface. Start the stroke by standing the brush on its chisel edge, then slide it toward yourself to create a short, thin line.

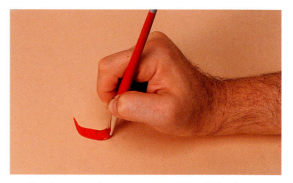

2 Begin to apply pressure as you slide the brush along the surface, gradually increasing pressure until you reach the middle of the stroke. Gradually release the pressure as you continue to slide the brush.

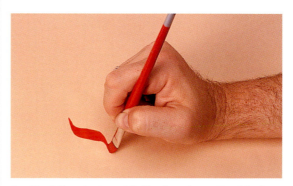

3 End the stroke with the brush on its chisel edge to create another short, thin line. The angle of the lines at the beginning and end of the stroke should be the same.

U STROKE

The procedure for making a U stroke is similar to that for the S stroke (see opposite) except that the shape of the stroke is different.

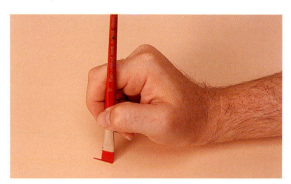

1 Stand a loaded flat brush on its chisel edge. Pull it toward you to make a short, fine line . . .

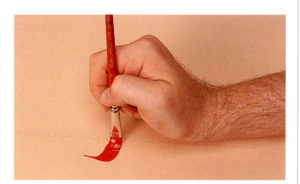

2 then gradually apply pressure to form the wide part of the U. Don't turn the brush, just slide it to the right or left.

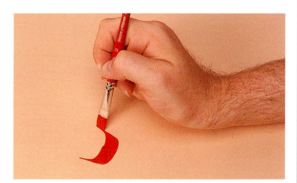

3 To complete the stroke, gradually release the pressure on the brush until it's standing on its chisel edge once again.

LINEWORK

Linework is done with a script liner brush using paint that has been thinned to a consistency similar to that of drawing ink so that it flows freely from the brush. If the paint is too thick, it either won't flow from the brush or it will produce thick, unattractive lines. To load the brush, completely fill the hairs with paint (see page 26), then gently twirl them to a fine point as you remove them from the puddle of paint. You need to apply only the slightest pressure to create fine lines and squiggles, and it takes practice to develop the light touch you need.

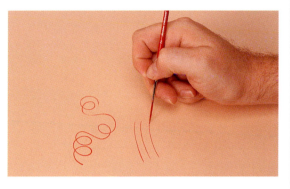

It's fun using one brush to create several different effects.

HANDLE DOTS

Handle dots aren't brushstrokes per se, but they are made with a brush—the handle end! Simply dip the handle into a puddle of paint, then touch the handle to the surface to create a perfectly round dot.

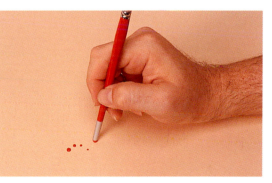

To make a series of uniform dots, reload the handle before making each one. To make a series of progressively smaller dots, just load the handle once.

29

Choosing and Using Color

Once you've practiced the brushstrokes shown on the preceding pages you can think about tackling one of the projects, but before you start painting you should familiarize yourself with some basic color theory.

A *color wheel* makes it easy to understand relationships among colors, which can in turn help an artist create successful mixtures. The standard artist's color wheel includes twelve colors. The three *primary colors*—red, yellow, and blue—are the ones from which all others are mixed, but they can't be mixed from any others. Theoretically, you should be able to make any color using just red, yellow, and blue paint, but the realities of paint chemistry require that we use a few more.

The primary colors lie equidistant around the color wheel. By mixing two primaries you get a *secondary color*. The three secondaries—orange (red + yellow), green (blue + yellow), and violet (red + blue)—lie between the primaries on the wheel. Mix a primary and a secondary and you'll get a *tertiary color*, of which there are six: red-orange, yellow-orange, blue-violet, red-violet, yellow-green, and blue-green.

Colors that lie directly opposite one another are called *complements*, a word derived from the Latin word *complementum*, meaning "to complete," which in this case refers to a complete grouping of three primary colors. For example, yellow and violet are complements; yellow is one primary, and violet contains the other two (red and blue), which completes the primary triad. In theory, mixing two complements creates a neutral, grayish color, but the result is often a murky color known informally as "mud."

The following are some tips for creating successful color mixtures:

- Mix colors according to the sequence cited in the instructions. The first color called for is the dominant color in the mixture. For instance, if the instructions call for a mixture of titanium white + Prussian blue, begin with a small puddle of white paint and add tiny amounts of blue until the desired color is reached.
- When creating a mixture, always add color in very small amounts. It's always easy to add color, but very difficult to reverse the effects of adding too much. At that point, it's usually easier to start over again than to fix it.
- So that each paint color will remain pure, get into the habit of wiping your palette knife before using it to pick up a new color or to add more color to a mixture.

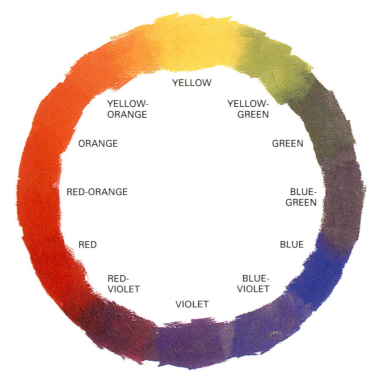

In addition to illustrating various mixtures, a color wheel shows that primary colors are the most intense because they are pure; the secondaries and tertiaries are less intense because they are mixtures. Cool colors fall on the blue-green side of the wheel, while warm colors are on the red-orange side.

YELLOW

YELLOW-ORANGE

YELLOW-GREEN

ORANGE

GREEN

RED-ORANGE

BLUE-GREEN

RED

BLUE

RED-VIOLET

BLUE-VIOLET

VIOLET

How Value Works

The term *value* refers to how light or dark a color is. When we describe a color as light yellow or dark blue, we're referring to its value. This concept is most clearly illustrated by a *value scale*, which consists of progressive gradations of gray, ranging from white at one end of the scale to black onthe other. Although every step in the scale can be identified as "gray," each is a different value.

Every color can be lightened and darkened to create a range of values. Why is this important? Because by using a range of values in your painting, you can give an object dimension. As you can see below, a circle that's painted with just one value looks flat. But a circle can look like a three-dimensional sphere when it's painted with a range of values.

The most obvious way to change a color's value is to add white or black to it. While this might work well in theory, in practice this can change a color too drastically. Colors can also be lightened and darkened by mixing them with other colors, a strategy that often yields better results. For instance, if you add black to yellow you'll get a greenish hue—an outcome most people wouldn't expect—but if you want dark yellow, you should add a small touch of violet (yellow's complement), or perhaps an earth tone like yellow ocher or raw sienna.

Don't let the occasional uncertainty of color mixing undermine your enthusiasm or your self-confidence. The project instructions will guide you and help you make good choices.

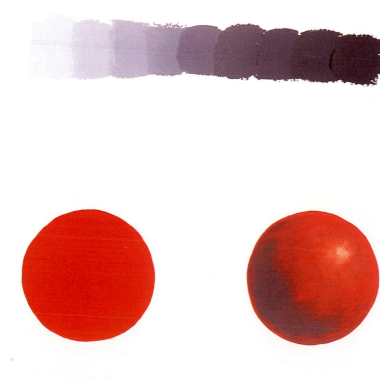

This ten-step value scale illustrates the range of values that can be created by incrementally mixing white and black.

(Far left) If you paint a circle with a single value, it still looks like a circle, but if you paint it with several values, arranging them to create the illusion of form *(near left),* the circle becomes a sphere.

Blending Techniques

Although blending techniques weren't typically used in most styles of American folk art painting, I've used them in the projects because they simulate some of the original techniques without having to go through as many steps.

BEFORE BLENDING: APPLYING AN UNDERCOAT

An essential decorative painting skill, *undercoating* simply means to paint an element with a single solid color. There are two ways to undercoat a motif: by applying the paint smoothly, or by giving it a slight texture.

A smooth application is the more traditional method. To achieve a smooth undercoat, simply load a brush—usually a flat brush—with paint straight from the bottle or tube. Using the brushstrokes demonstrated on pages 27–29 (or variations of these), begin applying the paint around the motif's outer edges, then smoothly stroke it toward the center of the motif until it is completely filled in. There shouldn't be a defined ridge around the motif's edges, and the paint shouldn't have a noticeable texture. If the color or texture of the basecoat is still visible once the paint has dried, apply a second coat, but not before making sure that the first is dry.

If the project instructions call for a textured undercoat (the Pennsylvania-Dutch distelfink motif shown on page 61 requires one), start by applying the paint around the motif's edges. As you fill the interior of the motif with color, use the chisel edge of the brush to stipple the paint slightly. Since this method of application breaks the surface of the paint, it's very likely that two coats will be needed. Apply the second coat using the same technique, making sure that the first coat is dry before you begin. Avoid creating a noticeable buildup of paint—the goal is simply to produce a slightly irregular texture.

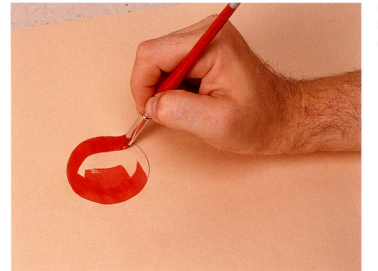

Begin undercoating by applying paint around the motif's outer edges, then smoothly stroke it toward the center.

DRYBRUSH

In the drybrush technique, one translucent layer of paint is applied over another as soon as it's completely dry, so that the two colors or values merge visually to create a third. This effect is known as *optical blending* because the colors aren't actually blended together but appear to be. Drybrush is particularly suited to creating subtle highlights, which are gradually built up with several thin applications of paint straight from the bottle or tube, each of which is progressively lighter in color and covers a smaller area than the one before. You can begin to drybrush once the undercoat is dry.

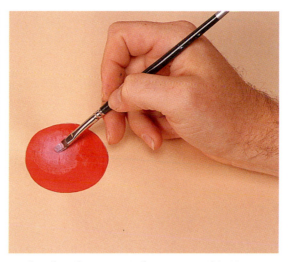

2 Let dry, then repeat the process, this time using a slightly lighter color and applying it over a smaller area.

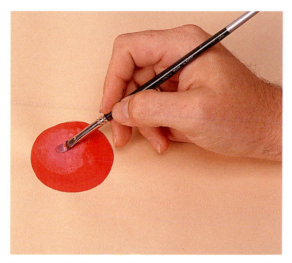

I Load the brush with just a scant amount of paint in a slightly lighter value than the undercoat, wipe it on a paper towel, then gently skim the hairs across the surface.

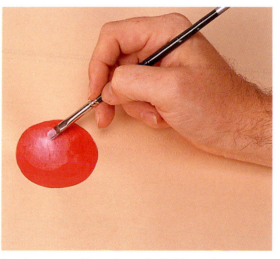

3 As you continue to apply lighter values, think of the highlight as a pyramid, with each area getting smaller and lighter until you reach the peak, which is usually a small area of white.

Blending Techniques

SIDELOADING

Sideloading is an invaluable blending technique that is used to create dimension within a motif. Instead of applying several layers of paint to create a gradual progression of color or value, as is done in the drybrush technique (see page 33), a sideloaded brush is loaded with paint in such a way that its stroke gradually fades from full color on one side to little or no color on the other, an effect that is known as *floated,* or gradated, color.

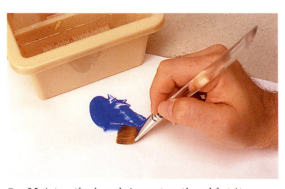

I Moisten the brush in water, then blot it on a paper towel. So that you don't pick up too much color on the brush, slowly stroke one side of the brush next to the puddle of paint, almost as if you're "sneaking" the brush into the paint as you carefully work it into the hairs.

TROUBLESHOOTING

- If you make your strokes longer than an inch (A), or if you make more than one set of strokes, you'll be painting the palette and removing paint from the brush instead of distributing it across the hairs. Keep stroking the brush in the same area, as long as the paint remains moist.
- If the paint beads up on the palette (B), or if the paint extends across the entire width of the brush, then the brush contains too much moisture. Gently blot the brush on a paper towel and try again.
- If the paint seems to drag (C), or if the brush doesn't have enough moisture in it, dip the corner of the more heavily loaded side into the water. This area of the brush will absorb less moisture, giving you more control over how much water is in the brush. Be sure to blot the brush on a paper towel any time you add moisture to it.

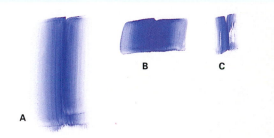

A B C

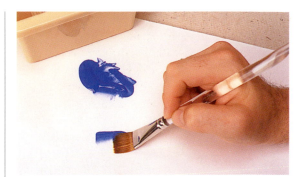

2 To distribute the paint across the brush, move to a clean area of the paper palette and stroke the brush over and over *in one spot*. The color in the stroke should *gradually* fade from full-strength on one side to clear water on the other. Be sure to make your strokes only about an inch long.

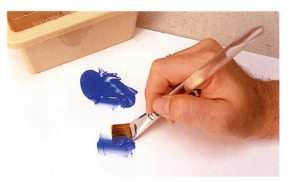

3 Working in the same spot, flip the brush over and repeatedly stroke the loaded side of the brush against the full-strength edge of the stroke.

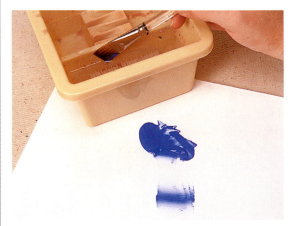

4 The brush should be properly sideloaded at this point; if it isn't, repeat steps 1 through 3. See the box at left for advice on how to correct and/or avoid other common sideloading problems.

DOUBLELOADING

A variation on sideloading, *doubleloading* loads each side of a brush with two different colors or values of paint. In the stroke produced by this technique, the two colors or values on either edge gradually blend to create a third color or value in the center.

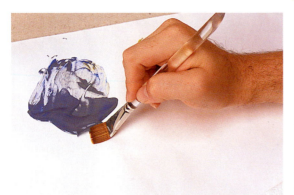

I Moisten the brush with water, then blot it on a paper towel. Load one side of the brush with the first color by "sneaking" it into the paint as you stroke it along the edge of the pile.

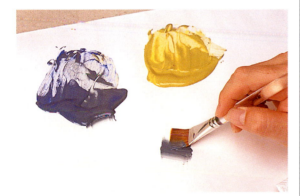

2 To distribute the paint halfway across the brush, stroke it *in one spot* on a clean area of the palette. Don't make your strokes more than about an inch long or the paint will begin to discharge from the brush. Flip the brush over, then stroke the more heavily loaded side against the full-strength edge of the stroke.

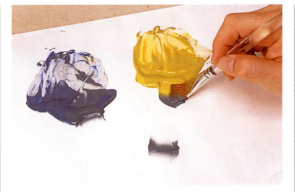

3 Repeat step 1 to load the empty side of the brush with the second color.

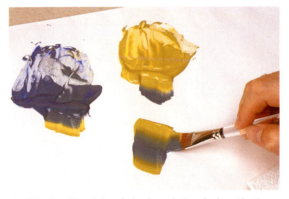

4 Stroke the side of the brush loaded with the first color against the same color on the stroke. Flip the brush and repeat on the other side of the stroke. Pay attention to what you're doing: Don't put the wrong edge of the brush into the wrong color. Load the brush with a little more of each color and continue stroking until the brush is full of paint.

TROUBLESHOOTING

- If the two colors aren't blended enough (A), pick up more paint and continue stroking in the same spot until the two gradually blend together.
- Sometimes the stroke becomes overblended, which muddies the colors on the palette as well as in the brush (B). To correct this, wipe the brush on a paper towel before starting again, but don't clean the brush completely or you'll undo all the good work you've done to fill it with paint.

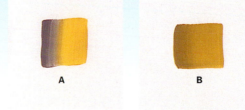

A B

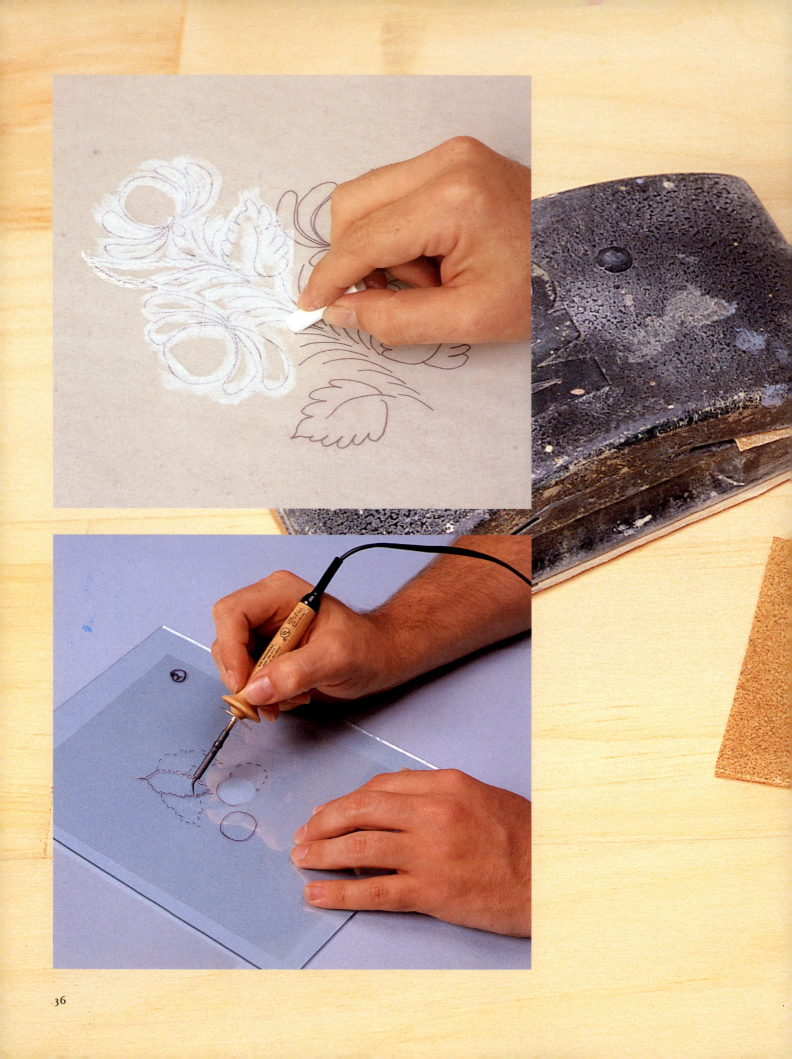

3 | The Painting Surface

Preparing Metal

Metal is one of the trickiest surfaces to prepare, but when it's prepared correctly it's one of the nicest to paint on. Paint that is applied to an improperly prepared metal surface will flake off, or eventually be overcome by rust, so it's important to get the preparation right from the start.

CLEANING

OLD METAL If an older piece is dirty or rusty, wash it with a pastelike mixture of dishwasher detergent powder and water, or use dishwasher gel straight from the bottle. Be sure to wear rubber gloves, as the detergent can burn your skin. Scrub off as much grime as you can, using a scrub pad, steel wool, or a product like Brillo or SOS to help things along. Rinse the piece thoroughly, allow it to dry, then apply Naval Jelly to remove rust and etch the surface, carefully following the manufacturer's instructions.

To strip already painted metal, use a commercial paint remover. (Naval Jelly alone is often effective.) Never strip or repaint a piece of decorated metalware without first having it evaluated by a reputable antiques appraiser to determine its age and value. Although the condition of an older piece may be fair or poor, which undercuts its decorative appeal, it may in fact be quite valuable.

NEW METAL New pieces are typically finished with a factory-applied oily coating that not only prevents rust but also prevents paint from adhering to the surface. Wash the piece with a 1:1 mixture of vinegar and water to remove the coating, rinse it well, then let dry completely.

PRIMING

Once your metal piece is clean and dry, it's ready for priming. Use a high-quality enamel primer

Prime every nook and cranny of your metal project's surface by working the spray in a smooth, side-to-side motion.

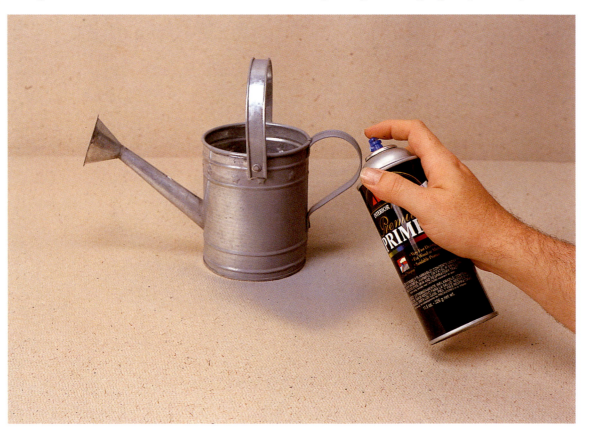

formulated specifically for use with metal. I use a spray-on primer that dries to a flat gray finish, which provides an ideal surface for the basecoat. To ensure adequate ventilation while working with the spray, set up outdoors on a warm (but not breezy) day; it's also advisable to wear eye protection, a respirator, and gloves, since the spray generates hazardous mists. Place the piece and the primer in your work area for a few hours (avoiding direct sunlight) to bring them to the same temperature. To apply the primer, hold the can about 8 to 10 inches from the surface and work it in a back-and-forth motion. (If you hold the can any farther away, the primer will actually dry before it lands on the surface.) Minimize runs and drips by applying three or four light coats of primer instead of just one thick one, letting each coat dry before applying the next. Let the final coat dry thoroughly—preferably overnight—before applying the basecoat.

BASECOATING

A basecoat can either be brushed or sprayed on a primed metal surface. Conveniently, you can use acrylic paint straight from the bottle or tube for this purpose. As with primer, it's best to apply a few thin coats rather than a single heavy one.

Once the paint is dry to the touch, and if a piece isn't too large, I like to heat-cure it in an oven, which accelerates the curing process and hardens the surface. Preheat the oven to 200°F, then turn it off before you put the piece in. I usually place my pieces right on the rack, but you can put down a sheet of aluminum foil if you prefer. Remove the piece when the oven is completely cool. While the oven is cooling, attach a note to it advising that it be left off until the piece has been removed, as temperatures above 200°F could blister the paint or melt the solder. Note that heat-curing is optional; you can simply let the piece dry overnight before proceeding.

I prefer to basecoat my metal projects with a brush-on paint because it gives the surface a rustic look.

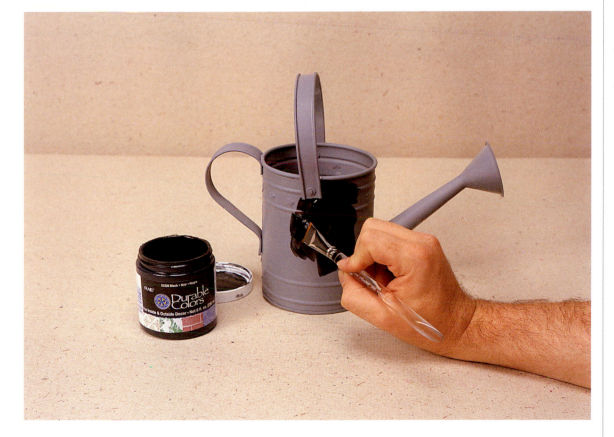

Preparing Wood

The guidelines below apply to the preparation of new, unfinished wood. If you would like to repaint an already finished piece, you can prime and basecoat it without stripping it first, as long as the wood is in good condition and the finish isn't flaking off or peeling away. If the piece is in poor condition, strip it with a commercial paint and varnish remover following the manufacturer's instructions. When the stripping process is complete, putty, prime, and sand the piece as needed, then proceed with basecoating and decorative painting.

APPLYING WOOD PUTTY

The first step in preparing a wood surface for painting is to fill in any nail holes, dents, or imperfections with wood putty. Pick up a small amount of putty with a clean palette knife and apply it to the affected area, smoothing out the surface and slightly overfilling any concave areas. Follow the manufacturer's directions with regard to drying times. At this point, the piece is ready for either priming or sanding.

PRIMING

This step generally isn't necessary unless a piece has many knots or you plan to basecoat it with a light color. If you do need to prime a piece, don't spend time sanding it before you prime it because the primer will "raise" the wood grain, or cause it to swell, which requires sanding anyway. Apply one coat of good-quality, white-pigmented primer with a wash brush or a glaze/varnish brush (the size of the piece will guide your choice of brush), then let it dry according to the manufacturer's directions.

Working with a sanding block—a small rubber or wooden block to which a piece of sandpaper is attached—can make the sanding process a little easier.

SANDING

If you haven't primed your piece, sand it with medium-grade (#220-grit) sandpaper; if you have, sand it with a fine grade (#400 grit) or with a scrub pad. Always sand in the direction of the wood grain, and try to keep your sanding strokes straight and even. You only need to sand until the wood feels smooth to the touch.

When you're finished, wipe the entire piece with a tack rag, making sure that even the finest grains of sanding residue have been removed from the surface. Don't skip this step; if you do, the residue can make your basecoat look grainy or flawed.

BASECOATING

You can basecoat wood with any color or brand of acrylic or latex paint that you prefer. The most widely available and convenient choice for small projects are 2-ounce squeeze-bottle craft acrylics, which can be purchased at most art supply and craft stores.

Use a natural-bristle or mixed-hair wash brush or glaze/varnish brush to apply the paint. These brushes are more responsive and provide better coverage than the foam-type sponge brushes that are currently popular. Dip the hairs about halfway into the paint, then apply the paint to the surface in smooth strokes. Let this coat of paint dry completely, then assess its finish: If it isn't smooth and opaque, sand it lightly with #400-grit sandpaper, wipe it with a tack rag, then apply a second coat. Allow the second coat to dry completely before proceeding with decorative painting or any other background treatment (see "Antiquing," page 43).

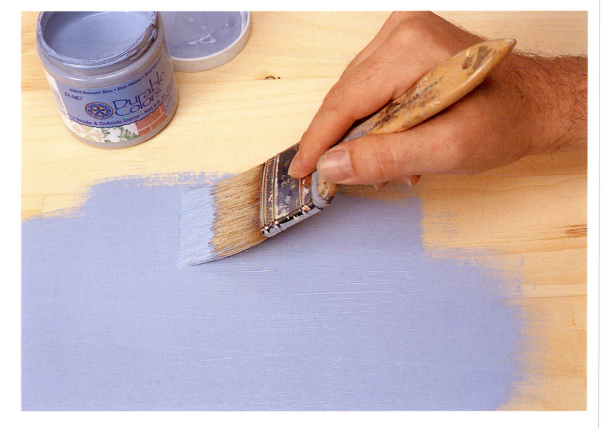

Always apply the basecoat in the direction of the wood grain.

Preparing Other Surfaces

Metal and wood were the two most prevalent painting surfaces in American folk art and are featured in many of the projects, but there were some decorative painting styles that made use of other surfaces.

GLASS

Glass is the painting surface in the tinsel painting project (see page 76). Clean both sides of the glass by wiping them thoroughly with rubbing alcohol or a commercial glass cleaner and a clean, lint-free cloth, then let dry. So that the paint will adhere to the glass properly, apply a thin, even coat of glass and tile medium to the back of the glass and allow it to cure at least overnight. (A full 48 hours would be best, since the longer the medium is allowed to cure, the harder and more durable it becomes.) Once dry, the medium looks milky or cloudy but will grad-ually cure to a clear finish, usually once the painting is complete.

PAPER

Good-quality watercolor paper requires no preparation prior to painting. A medium-weight paper is used in the Fraktur project (page 56).

FABRIC

For fabric painting projects that will require periodic laundering, such as T-shirts and other wearables, the fabric should first be washed to remove any sizing, then dried and ironed flat. In contrast, the velvet that is used as the support for the theorem painting project (page 80) doesn't require prewashing, as the finished piece is purely decorative. If the fabric is wrinkled, press it with a warm iron, using a pressing cloth or terrycloth towel to protect it.

Decorative painting projects on fabric, paper, and glass.

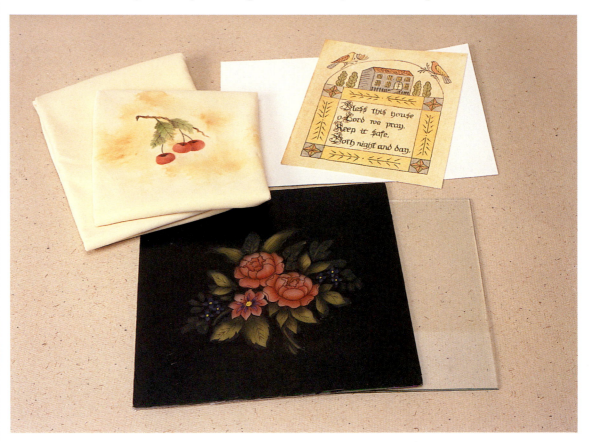

Antiquing

An antiquing glaze—a translucent wash of color applied, then partially removed, to create a patina of age—can add a wonderful, rich look to designs painted on metal and wood. You can apply an antiquing glaze over a basecoat prior to painting a design, or over a completed design.

Before you can begin antiquing, you must create the glaze. Mix equal amounts of paint and Glazing Medium with a palette knife until they are thoroughly combined, and the consistency of the mixture is similar to thick soup. To extend the glaze's working time, add an amount of gel retarder equal to the entire volume of the mixture.

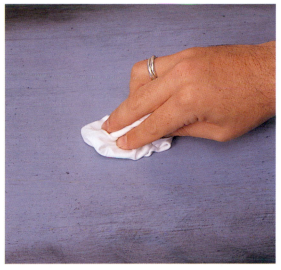

2 While the glaze is still wet, use a soft cotton rag to wipe away the glaze from the center of the surface, working in a circular motion from the center outward to create an attractive highlighted area.

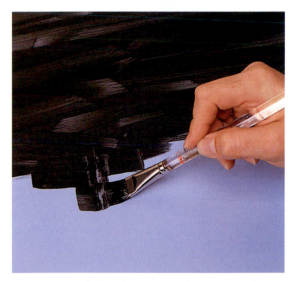

1 Use a wash brush to apply the glaze to the surface in a random manner. Be sure to completely cover the area you want to antique.

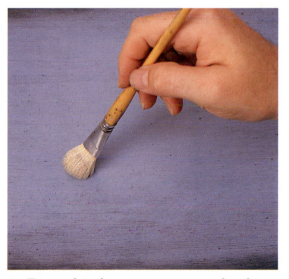

3 To complete the process, use a mop brush to soften and refine the glaze that remains on the surface. Holding the brush so that the bristles just graze the surface, create a subtle gradation from light (in the center) to dark (at the edges of the surface) and eliminate any obvious marks left by the wash brush or rag in steps 1 and 2.

Tracing, Sizing, and Transferring Patterns

The decorative painting patterns at the back of this book are provided for your use and enjoyment. You may use them as is, simplify them by eliminating elements, or embellish them by adding elements from others. Working with an accurately traced, sized, and transferred pattern will make your decorative painting experience more pleasant.

TRACING AND SIZING

Place a sheet of tracing paper over the pattern and carefully outline its contours with a fine-tip black marker. If the traced pattern fits the painting surface, you can simply transfer it using one of the two methods described on the opposite page. If you need to adjust the size of the pattern to fit the painting surface, you can enlarge or reduce the tracing on a photocopier. To determine the correct percentage of enlargement or reduction, use a *proportional scale,* which consists of two concentric discs whose circumferences are printed with a series of measurements. In one of the disks is a window that, when turned, reveals a sequence of percentages. Simply measure the traced pattern's height or width, then figure out what that dimension should be in order for the pattern to fit on the surface. When you line up these two numbers on the disks, the correct percentage of enlargement or reduction will appear in the window.

I use two pattern transfer techniques, both of which are shown on the opposite page: the transfer paper method and the chalk transfer method. Either method can be used with any pattern, but the chalk transfer method is better suited to stroke designs because the chalk dissolves more readily when paint is applied, and can't be seen through the paint even when it doesn't.

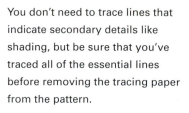
You don't need to trace lines that indicate secondary details like shading, but be sure that you've traced all of the essential lines before removing the tracing paper from the pattern.

When tracing a strokework pattern, trace a single line down the center of each stroke to indicate its size and position, which leaves you free to paint without having to fill in or conform exactly to the transferred pattern.

44

TRANSFER METHOD 1: TRANSFER PAPER

I Position the correctly sized pattern on the prepared surface. Tape it in place if you think it might slip, but don't affix the tape with much pressure—use just enough to hold the design in place. Slip a piece of transfer paper under the pattern, make a test mark with the stylus, then lift the pattern and the transfer paper to make sure that the right side of the transfer paper is against the surface. (This is an important habit to cultivate, since it's a frustrating waste of time to transfer a pattern to the back of itself.)

2 Carefully trace all of the pattern lines with the stylus, periodically lifting both the pattern and the transfer paper to see whether you've missed any. One caveat: Don't press hard or you might dent or groove the surface. When you're done, simply remove both sheets and you're ready to paint.

TRANSFER METHOD 2: CHALK TRACING

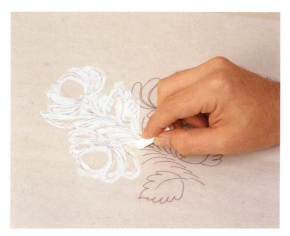

I Turn the correctly sized pattern face down and carefully trace its lines with a piece of chalk. Do *not* scribble all over the back of the pattern. Gently shake the pattern (but not near the prepared surface) to remove excess chalk.

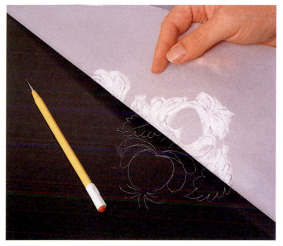

2 Position the pattern chalk side down on the prepared surface, taping it in place if necessary. Use a stylus to trace over the lines. Periodically lift the pattern to make sure you've transferred all of its lines, and that the transferred image is clear.

Tracing and Cutting Stencils

In this book, stencils are used to recreate two American folk art techniques: theorem painting (page 80) and bronzing (page 84). The process of cutting a multipart stencil—a complex stencil comprising several overlays—isn't difficult, but it does require care and precision. If each overlay isn't accurately traced and cut, the print will contain unsightly gaps and overlaps. If you work slowly and deliberately, you should succeed on your first attempt, and your reward will be an image that can be used again and again, in many different projects.

To complete this task, you'll need a fine-tip black marker, several sheets of acetate or Mylar, a piece of ordinary window glass, and a stencil burner. (See page 23 for descriptions of these special stenciling supplies.)

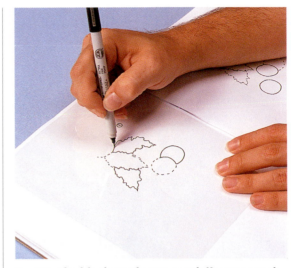

1 Use the black marker to carefully trace each stencil overlay on a separate piece of acetate or Mylar. Note that the solid lines are the ones that will be cut, while the dashed lines are registration guidelines for layering the overlays.

2 Double-check each overlay to ensure that it matches the printed version in the book, then number it so that it will be stenciled in the proper sequence.

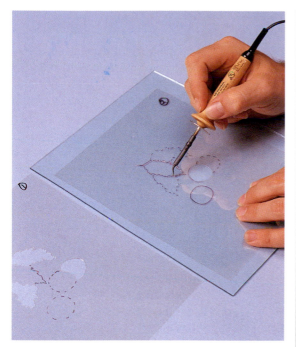
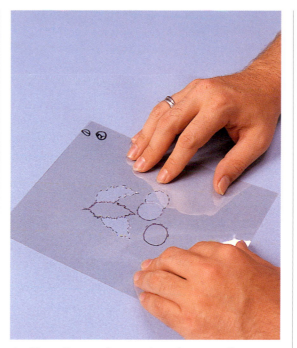

3 Working with a stencil burner can be tricky at first, so you should practice this step a few times on a scrap piece of acetate or Mylar before you cut your overlays.

Place one of the overlays on the glass, then gently guide the hot tip of the burner at an even rate of speed over *the solid lines only*. There's no need to exert intense pressure on the burner; its heat alone can easily melt the plastic, yielding a nice, clean cut. Note that the tip will burn the plastic if you hold it in one place for too long. Repeat for the remaining overlays.

4 Place the overlays on top of one another, carefully aligning the dashed registration guidelines so that you can assess whether all of the elements line up. Here, two of four overlays are being checked for alignment.

- If an overlay contains an *overlap*, or a small area between two adjacent motifs that wasn't removed during the cutting step, carefully mark the area, then return the overlay to the glass and remove it with the burner.
- If an overlay contains a *gap*, or an area between two adjacent motifs that was mistakenly removed during cutting, retrace it on a new piece of acetate or Mylar and cut it again.

Don't try to stencil a poorly cut overlay—you won't be able to finesse it into alignment.

STENCILING ESSENTIALS

Before you begin stenciling, take a moment to consider the process. Color is applied to each overlay several times, so that the image emerges gradually. Each time a set of overlays is placed on the surface, their elements are painted with the same value. As you work, remove each stencil before positioning the next one on the surface.

- *In the theorem painting project,* the local colors, which are typically medium in value, are applied first. During the second pass, each element is shaded. In the final pass, the details are added. In this case, it isn't necessary to add highlights because the white of the velvet provides them naturally.
- *The bronzing project* is a little different. In that example, similar values are applied during each pass, but the darkest value of metallic wax is applied first, then the medium value, then finally the light value.

Varnishing

The procedure for varnishing is fairly simple, but you must use the proper tools to achieve satisfactory results. Before you begin, make sure that your painting is sufficiently dry. If you're working with acrylic paints, you should wait at least 24 hours after completing the project before varnishing.

APPLYING BRUSH-ON VARNISH

Use a top-quality natural-bristle brush to apply brush-on varnish. A glaze/varnish brush is an excellent choice for this task, as it holds plenty of varnish and releases it in a controlled and even manner. Never apply varnish with a foam brush, which will leave bubbles on the surface—something you definitely want to avoid.

Using the right kind of brush is essential, but its care is important too. I recommend that you purchase a new glaze/varnish brush and set it aside for varnishing only. In fact, I labeled the handle of one of my glaze/varnish brushes so there would never be any question as to which one should be used for varnishing. Why earmark a brush exclusively for varnishing? The answer is simple: If you use a brush to apply paint, traces of it may remain in the bristles even after it has been cleaned. Good-quality water-based acrylic polyurethanes, like the FolkArt and Varathane brands I use, contain chemicals that can loosen and soften this residue, which then may be transferred to the painted surface or leave unsightly streaks of color in the varnish. Wash your varnish brush immediately after applying each coat to prevent a buildup of varnish in the hairs.

Before you begin applying it, stir the varnish thoroughly until none of the cloudy "stuff" (dulling agents) is left in the bottom of the container. (Never shake a can of varnish, as shaking

When applying brush-on varnish, flow it on the surface in a uniform layer, working the brush in one direction. Apply a total of three coats, letting each coat dry before applying the next.

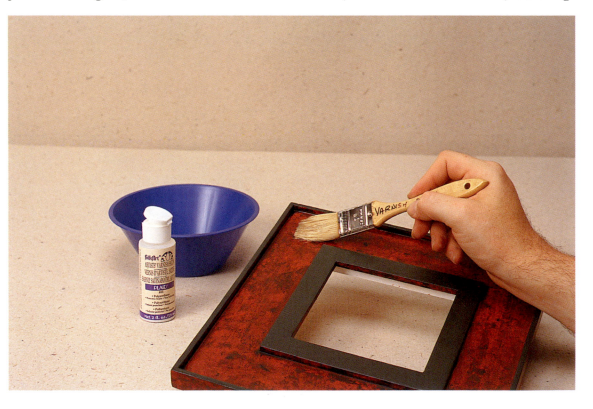

produces bubbles.) If you don't distribute the dulling agents throughout the varnish by stirring it, it will become increasingly dull as you use up the can, and will eventually cloud your finish.

After stirring the varnish, dip the brush into it, then even out the load on the hairs by scraping its side against the inner rim of the container. This is done to avoid either "flooding" the surface with varnish or applying so little that you have to scrub it with the brush. Let the first coat dry, then repeat the process to apply two more coats. Three coats of varnish should provide adequate protection for your work.

APPLYING SPRAY VARNISH

When finishing an intricately cut or carved wooden or metal piece, acrylic spray varnish provides a solution to the problem of applying an even coat to every nook and cranny. Spray varnish comes in a range of sheens, from gloss to matte. I like either a gloss or a satin finish for my American folk art projects because I find that a matte finish dulls down the painted designs. Whatever brand or sheen you use, read and follow the manufacturer's directions carefully.

The fumes and mists that are by-products of spray varnish can be dangerous if your work area isn't properly ventilated—the rooms in most homes aren't designed for this task—so set up outdoors on a balmy but not breezy day. Leave the piece and the spray in your work area for a few hours to bring them to the same temperature. Apply a light coat of varnish, holding the can at least 8 inches, but no more than 10 inches, from the surface, moving it with a sweeping back-and-forth motion. As with brush-on varnish, it's best to apply three or four light coats rather than one or two heavy ones.

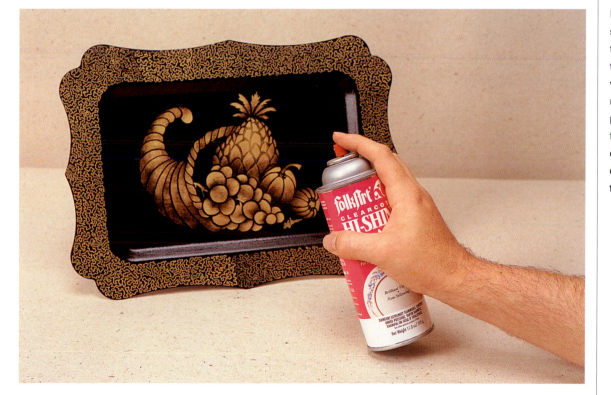

If you hold the can of spray varnish closer than 8 inches from the surface, the solvent in the varnish may reactivate the paint; if you hold it farther than 10 inches, the varnish may dry before it even touches the surface.

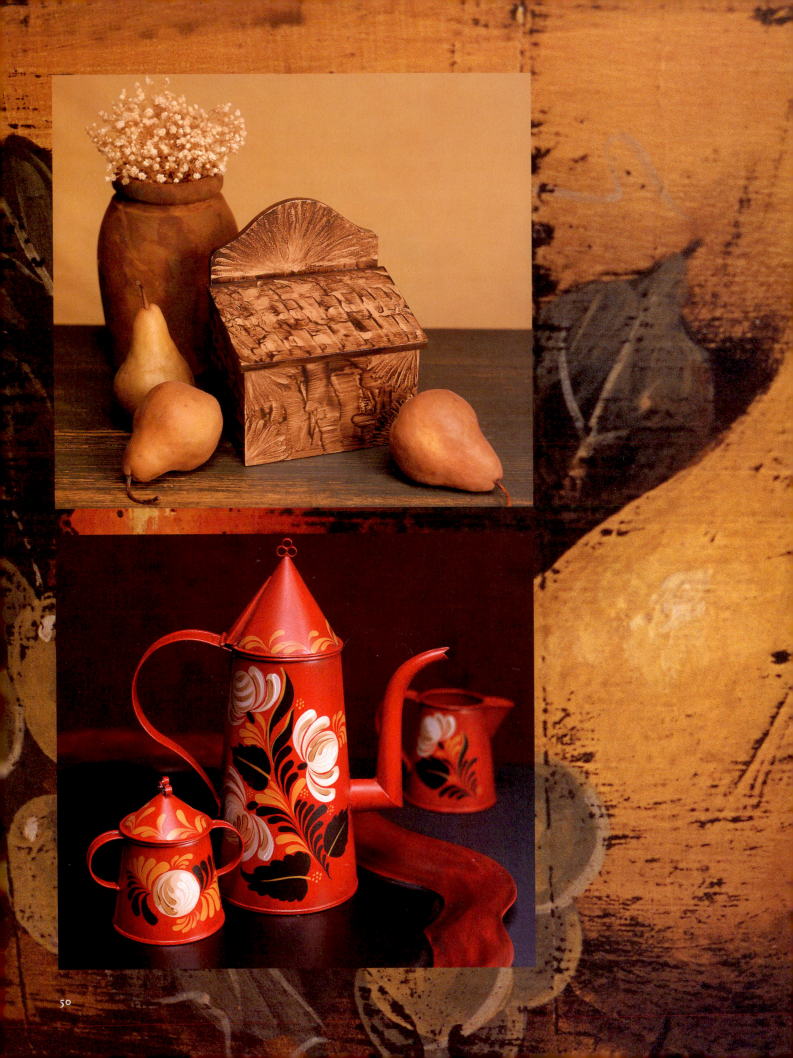

4 American Folk Art Painting Techniques

Colonial Graining

PUTTY-GRAINED SALTBOX

*N*o matter what it's called—country graining, vinegar graining, putty graining—Colonial graining is easy to do and remarkably appealing. The techniques are unrefined, and the results only vaguely resemble the grain patterns of real wood, but the naïve charm of surviving pieces is immeasurable. For this project, I recreated the putty-graining technique using acrylic paints and nondrying modeling clay instead of home-made paints and putty. The technique is extremely easy; you'll just need to allow for each surface to dry before graining the next. When selecting a piece for Colonial graining, choose one that isn't too formal in style or elaborately carved; in fact, the simpler and more casual, the better.

If you enjoy putty graining and would like to try other Colonial graining techniques, see the Fraktur painting project on pages 56–59, which features a faux mahogany frame, and the theorem painting project on pages 80–83, whose frame is sponged with a faux burl.

WHAT YOU'LL NEED

Project
Wooden saltbox from Wayne's Woodenware (see page 111 for ordering information)

Supplies

SURFACE PREP
Primer
#400-grit sandpaper
Tack rag
Basecoat paint: cappuccino (bright, light brown acrylic or latex)

ARTISTS' ACRYLICS
Burnt umber
(optional: pure black, asphaltum, and/or burnt sienna)

ACRYLIC MEDIUMS
Gel retarder

BRUSHES
$3/4$-inch wash brush
Two 1-inch glaze/varnish brushes (one for priming, one for varnishing)

BASIC PAINTING SUPPLIES
Palette knife
Water container
Paper towels
Wax-coated paper palette

SPECIAL PROJECT SUPPLIES
Nondrying modeling clay such as Permoplast or Plast-i-clay

FINISHING
Brush-on satin-sheen acrylic varnish

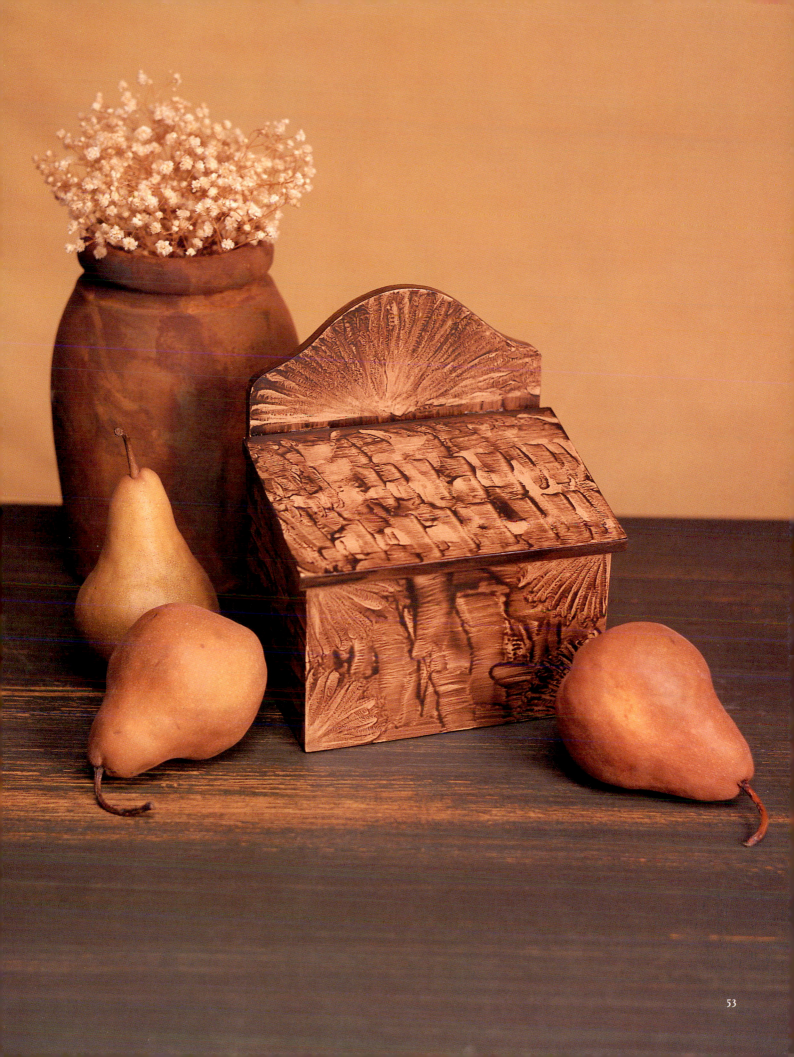

Colonial Graining

GETTING READY

Prime, sand, and basecoat the salt-box according to the instructions on pages 40–41. If a second coat of base-paint is needed, make sure the first is completely dry before applying it.

I Prepare the graining glaze by combining equal parts gel retarder and burnt umber paint. You may add some black to the mixture, or even some asphaltum or burnt sienna. Experiment to see which colors or combinations you like best.

Use the wash brush to apply the glaze to just one area of the box, like the top or one of the sides. (I started with the top.) Apply the glaze heavily so you'll have plenty of time to manipulate it in the next step, but not so heavily that it's messy or runny.

2 Roll a piece of modeling clay into a short snake, then roll it across the surface to create an interesting surface texture. The direction in which you roll the snake isn't important as long as it creates an evident pattern. If the snake becomes saturated with glaze, clean it by rolling it on a paper towel.

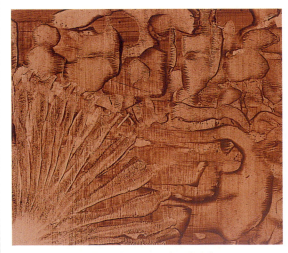

3 Let the surface dry completely, then repeat steps 1 and 2 on another surface. After texturing the glaze on the front of the box as described in step 2, I rolled the clay snake from one edge to the other at each corner to create a ray pattern.

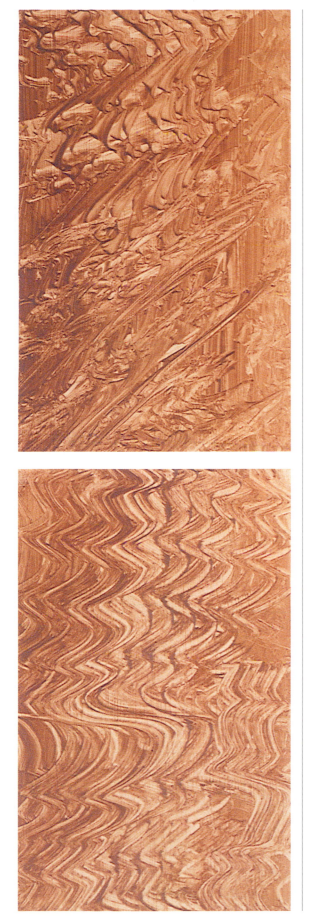

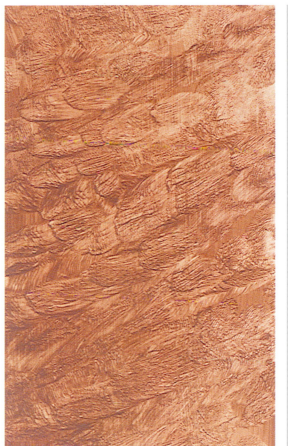

Let the graining
cure for a few days
before varnishing
the box with two
coats of varnish,
letting the first dry
completely before
applying the second.

4 Repeat steps 1 and 2 on the remaining sur-
faces, letting each dry before proceeding to the
next. Be adventurous: Try shaping the clay and
using it as a stamp instead of just rolling it, or
use another homemade tool like a torn piece of
cardboard, a piece of cork, or whatever else you
have around the house. If you don't mind getting
your hands dirty, you can even use your fingers!

When the graining is completely dry, trim the
edges of the box with burnt umber.

Fraktur Painting

HOUSE BLESSING IN A FAUX MAHOGANY FRAME

*H*istorically, Fraktur painting can be traced to the art of manuscript illumination. The German word fraktur refers to a printer's typeface called black letter, which is based on a style of handwriting used by medieval German scribes. Many examples of Fraktur painting feature an elaborate calligraphy based on these letterforms. Fraktur painting departs from manuscript illumination in that the painted design, rather than the text, is the dominant element of the composition. The motifs almost always held some personal significance, either for the artist or the recipient. My interpretation includes several common motifs, all rendered in a characteristically spare style.

Early examples of Fraktur painting were generally done on white paper, with the design outlined in black ink penned with a goose's quill. The delicate colors—homemade paints or dyes in soft yellows, reds, blues, and greens—were then applied with handmade cat-hair brushes. As you work, keep these humble implements in mind and realize that imperfection is part of this folk art's unique charm. Before you start, seek out reference materials and see for yourself the wide range of subject matter that can be found in antique Frakturs.

WHAT YOU'LL NEED

Pattern and Lettering
Page 96

Project/Painting Surface
180-lb. hot-press watercolor paper
Wooden frame from Hy-Jo Manufacturing Imports Corp. *(see page 111 for ordering information)*

Supplies

SURFACE PREP
(FOR THE FRAME)
Basecoat paint: light red oxide acrylic or latex
#400-grit sandpaper
Tack rag

TRACING AND TRANSFER
Tracing paper
Fine-tip black marker
Gray transfer paper
Stylus

ARTISTS' ACRYLICS
Yellow ocher
Red light
Burnt umber
Prussian blue
Sap green
Asphaltum
Pure black

ACRYLIC MEDIUMS
Gel retarder
Glazing Medium

BRUSHES
Foam sponge brush
No. 8 flat brush
3/4-inch wash brush
1-inch glaze/varnish brush
 (for varnishing)

BASIC PAINTING SUPPLIES
Water container
Palette knife
Paper towels

SPECIAL PROJECT SUPPLIES
Styrofoam plate
Cotton rag
Crow quill OR dip pen
Corrugated cardboard
Brown and black permanent waterproof ink
Cork-backed metal ruler

FINISHING
Brush-on satin-sheen acrylic varnish

Bless this house
o Lord we pray.
Keep it safe,
Both night and day.

Fraktur Painting

GETTING READY

Use the sponge brush to moisten the watercolor paper with clean water. Make sure the entire sheet is wet.

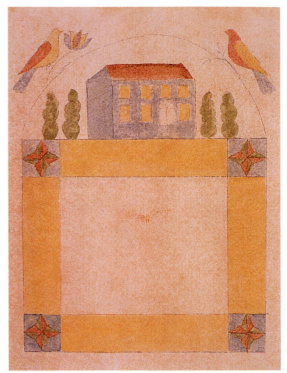

I In a Styrofoam plate, thin some asphaltum with water, mixing them together with the palette knife until the paint is very translucent. (This particular mixture is too watery for a paper palette.) Apply this wash to the dampened paper with the sponge brush, then gently wipe away the excess with a cotton rag. Don't rub too hard or you'll abrade the surface. The paper should have a soft brown "antique" tint to it. Let the paper dry completely before proceeding to the next step.

2 Trace and transfer the main elements of the pattern according to the instructions on pages 44–45. When tracing and transferring the straight lines of the pattern, use a ruler to guide your pen or stylus. Avoid making the lines of the transfer heavy or dark.

Thin all of the following colors or mixtures with gel retarder and a bit of water until the color is translucent. Use the flat brush to apply tiny amounts of color uniformly to each area, then let dry. If a color seems too light, you can apply additional washes.

- *Yellow = Yellow ocher.* Apply to the main areas of the square frame, the windows, the middle petals of the tulip, the body of the bird on the left, and the wing of the bird on the right.
- *Blue = Prussian blue + burnt umber.* Apply to the corners of the frame, the house, the birds' tails, and the outer petals of the tulip.
- *Green = Sap green + burnt umber.* Apply to the trees and alternating surfaces of the star.
- *Red = Red light + burnt umber.* Apply to the remaining surfaces of the star, the roof of the house, the center of the tulip, the wing of the bird on the left, and the body of the bird on the right.

Let the washes dry before inking the pattern.

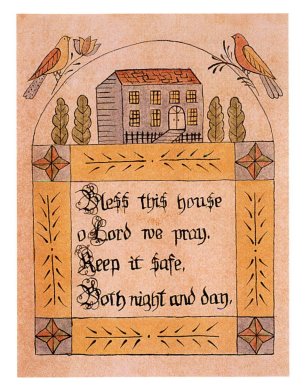

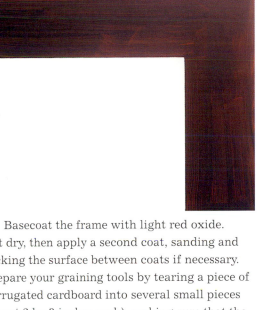

FINISHING

Finish the frame with two coats of varnish, allowing the first to dry before applying the second. Frame the Fraktur under glass.

3 Trace the blessing, then transfer it to the paper. Add just a drop of black ink to a small amount of brown ink, then load the dip pen with the mixture and use it to outline all of the design elements. Let each element dry before starting the next. Test the pen on a piece of scrap paper each time you dip it into the ink so that the ink won't blob off the nib. Draw in the wheat in the yellow areas of the frame, the trunk and branches of the trees, and the details on the house and the birds. Let dry, then ink the lettering.

4 Basecoat the frame with light red oxide. Let dry, then apply a second coat, sanding and tacking the surface between coats if necessary. Prepare your graining tools by tearing a piece of corrugated cardboard into several small pieces (about 2 by 3 inches each), making sure that the waffle portion of the cardboard is exposed on one edge of each piece. Use the palette knife to mix equal amounts of black and burnt umber, then combine that mixture with an equal amount of Glazing Medium. Apply this translucent earth-tone glaze with the wash brush to two sides of the frame. (Don't apply the glaze to the entire frame or you won't have enough time to create the graining in the next step.)

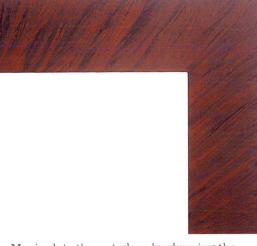

5 Manipulate the wet glaze by drawing the waffle edge of one of your homemade cardboard tools across its surface. Discard the tool once it becomes charged with glaze and continue with a clean piece. The grain pattern may be as deliberate or as random as you choose. On the example shown here, I drew the cardboard through the glaze at 45-degree angles on each quarter of the frame to simulate mahogany graining.

Pennsylvania-Dutch Motifs

DISTELFINK AND HEART ON A PIERCED TIN CONTAINER LID

*O*ne of the most widely recognizable Penn-Dutch hex symbols is the distelfink (German for "thistlefinch," a colloquial term for the goldfinch), which signifies good luck and happiness. In the design I created for this project, the distelfink is perched on a heart, a universal symbol of love. The original hex signs were painted almost exclusively with flat colors, but my adaptation involves a great deal of shading and highlighting, requiring solid brushstroke skills and a mastery of the drybrush technique. The process of adapting historical models to modern techniques and tastes gives artists an opportunity to add their own personal touches.

I painted my design on the wooden lid of a container constructed of pierced tin, yet another example of Penn-Dutch ingenuity. Traditionally, the tin was punched with holes to create a jagged texture on the outside of the object that kept insects out while permitting ventilation.

WHAT YOU'LL NEED

Pattern
Page 97

Project
Pierced tin container with
 wooden lid from Covered
 Bridge Crafts *(see page 111
 for ordering information)*

Supplies

SURFACE PREP
#220-grit sandpaper
Tack rag
Basecoat paint: burnt carmine
 (see list of artists' acrylics)

**TRACING AND
TRANSFERRING**
Tracing paper
Fine-tip black marker
White transfer paper
Stylus

ARTISTS' ACRYLICS
Titanium white
Yellow ocher
Medium yellow
Pure orange
Naphthol crimson
Alizarin crimson
Red light
Burnt carmine
Burnt umber
Brilliant ultramarine
Sap green
Payne's gray
Pure black

ACRYLIC MEDIUMS
Gel retarder

BRUSHES
3/4-inch wash brush
Nos. 8 and 10 flat brushes
No. 2 script liner
No. 6 OR 8 filbert
1-inch glaze/varnish brush

**BASIC PAINTING
SUPPLIES**
Water container
Palette knife
Wax-coated paper palette
Sta-Wet palette
Paper towels

FINISHING
Brush-on satin-sheen
 acrylic varnish

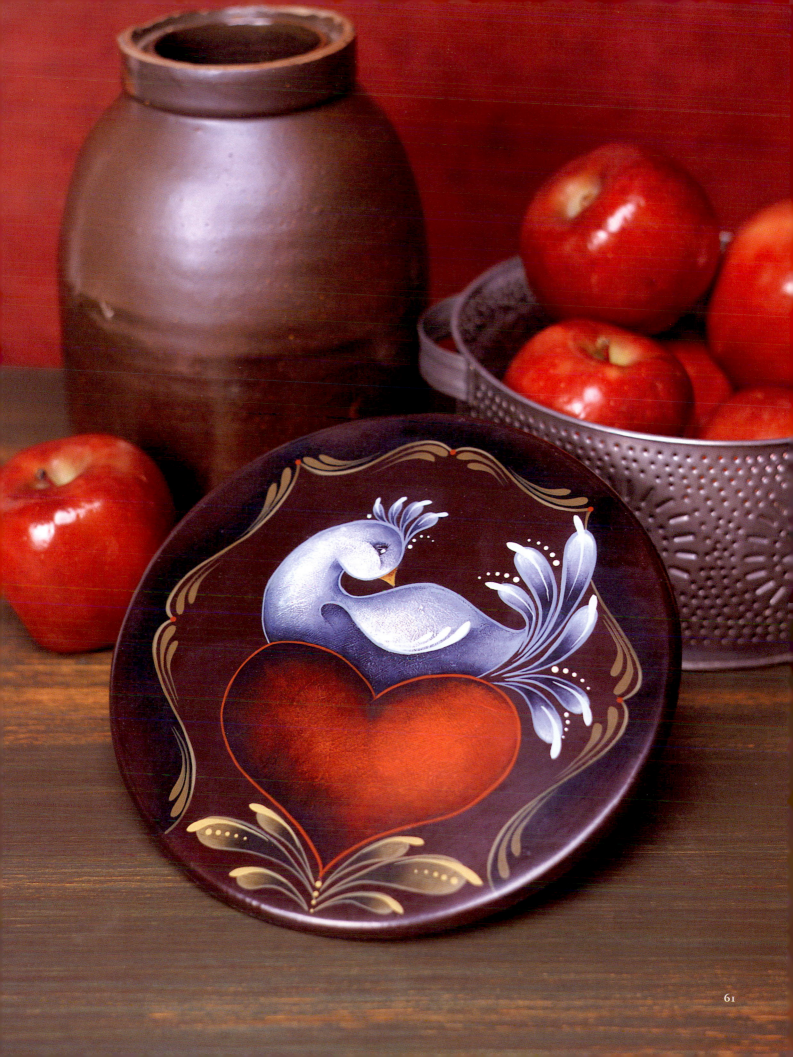

Pennsylvania-Dutch Motifs

GETTING READY

Following the instructions on page 40, sand and tack the lid, then basecoat it with burnt carmine. If the first coat isn't sufficiently opaque, let it dry completely and apply a second coat.

Trace and size the pattern according to the instructions on page 44, then use the transfer paper method (see page 45) to transfer only the scroll border to the lid.

Doubleload the wash brush with pure black and gel retarder. Shade the border, keeping the side of the brush that is loaded with black next to the line and the side loaded with retarder turned toward the edge of the lid. Although the shading is dark and somewhat difficult to see, it adds a nice touch to the piece. When the shading is dry, transfer the rest of the design to the lid.

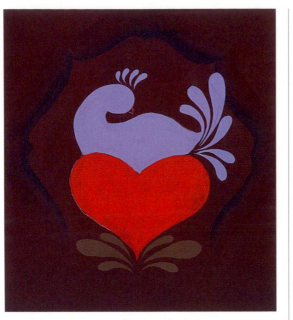

1 Using the largest flat brush that you can comfortably maneuver in each area, undercoat each element of the design, applying as many coats you need to achieve opaque coverage. Give the undercoat a slight texture (see page 32) in order to prepare it for the drybrushed highlights in steps 4 and 5.
- *For the bird* (except for the beak), use a dull, medium-value blue mixed from brilliant ultramarine + pure orange + a tad of titanium white.
- *For the heart,* use naphthol crimson.
- *For the strokes,* use a green mixture of yellow medium + pure black.

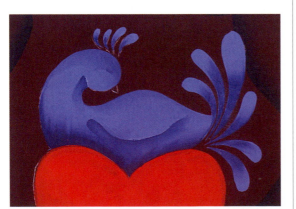

2 Shade the bird, again using the largest flat brush you can fit into each area. Doubleload the brush with gel retarder and a mixture of brilliant ultramarine + Payne's gray + a touch of pure black. Shade along the bottom of the bird where it rests on the heart, along the top of its head, under its wing, and at the base of each of the strokes that form its tail and crest.

3 Shade the left side of the heart with several layers of color using paint straight from the tube. The first layer, alizarin crimson, should extend almost halfway across the heart. Let the first layer dry, then apply the second, a darker mixture of alizarin crimson + sap green over the left quarter of the heart. If you would like to shade the heart even further, add a bit of burnt carmine to the second mixture and apply it to along the left edge.

Shade the base of each green stroke with a doubleloaded brush of pure black and gel retarder. Let dry thoroughly.

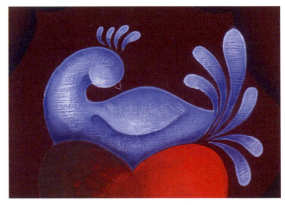

4 Use the drybrush technique (see page 33) to highlight the bird with several values of blue. Prepare the first highlight color by adding a touch of titanium white to the blue of the under-coat (see step 1). Load the filbert brush with a scant amount of this color, then lightly skim the hairs over the surface, concentrating on the perimeter of the bird's body and softening the edges of the shading. Let dry, then repeat to develop the highlight with several progressively smaller applications, gradually lightening the paint by adding a small amount of titanium white each time. The highlight should peak in the center of the neck and along the edge of the wing. Use the same procedure to highlight the ends of each feather in the crest and tail.

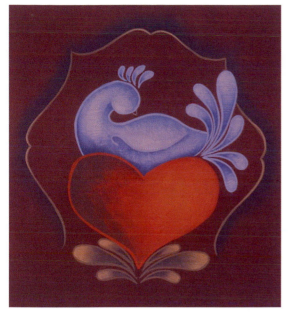

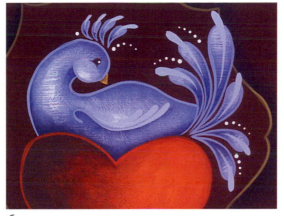

5 Again using the drybrush technique, add highlights to the right side of the heart and the end of each green stroke.

- *For the heart,* start with naphthol crimson, then move on through naphthol crimson + red light, to red light, to red light + a bit of pure orange, and finally pure orange.
- *For the green strokes,* begin with the green of the undercoat (see step 1), then lighten it with a bit of yellow medium for the second highlight, and again with a touch of titanium white for the final highlight.

To eliminate any messy edges, use the script liner and paint thinned with water to a thin, flowing consistency to outline each element of the design. Outline the bird with its undercoat color, the heart with a mixture of naphthol crimson + red light, and the green strokes with their undercoat color lightened with some yellow medium. Use this last color to paint the scroll border that surrounds the design, which can also be highlighted with a lighter-value green if desired.

6 Complete the bird by adding the following details, using the script liner and paint thinned with water to a flowing consistency:

- Paint the comma strokes on the bird's head and tail feathers with a light blue made by adding white to the undercoat color. Add a series of graduated handle dots in titanium white around the head and tail feathers.
- Undercoat the beak with yellow ocher, let it dry, then shade it with burnt umber.
- Undercoat the eye with Payne's gray + pure black, let it dry, then highlight it with titanium white.

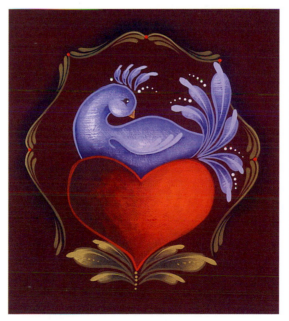

7 Using the script liner and the lightest highlight color that was mixed for the green strokes in step 5 (but this time thinned with water), make the comma strokes and the handle dots on the green strokes as well as the comma strokes surrounding the scroll border. Connect the segments of the border with handle dots of red light.

Lace-Edge Painting

METAL TRAY PAINTED WITH A STROKE ROSE AND NOSEGAYS

*L*ace-edge painting is unique among other styles of tray painting because the motifs were initially painted with semiopaque color, then accented with translucent over strokes that were given dimension with the addition of a waxy medium. The backgrounds of the trays were usually painted black, although there are dark green as well as some very fine faux tortoiseshell examples. The most common central motifs were flowers and fruits, which on round and oval trays were typically surrounded by small nosegays or a wreath of tiny flowers. The surrounding flowers were always much darker and duller than the central motif, an important characteristic of the style that was intended to direct the viewer's attention to the center of interest.

Unfinished pierced-edge tin trays aren't produced for the craft market today, but you may be lucky enough to stumble upon an old, already finished one in an antique store or at a tag sale that you can use for your surface. (Read the warning on page 38 before stripping or repainting any old metal pieces.) I adapted a traditional lace-edge design to fit a metal tray with a scalloped rim, around which I scattered little nosegays. This ambitious project requires a mastery of brushstroke skills and sideloading.

WHAT YOU'LL NEED

Patterns
Page 98

Project
Scallop-rim metal tray from
Barb Watson's Brushworks
(see page 111 for ordering information)

Supplies

SURFACE PREP
Spray-on flat-finish gray primer
Basecoat paint: pure black
(see list of artists' acrylics)

TRACING AND TRANSFER
Tracing paper
Fine-tip black marker
White chalk
Stylus

ARTISTS' ACRYLICS
Warm white
Yellow ocher
Red light
Alizarin crimson
True burgundy
Prussian blue
Sap green
Green umber
Pure black

ACRYLIC MEDIUMS
Gel retarder
Glazing Medium

BRUSHES
No. 6 filbert
No. 8 OR 10 flat brush
No. 2 script liner
3/4-inch wash brush

BASIC PAINTING SUPPLIES
Water container
Paper towels
Palette knife
Sta-Wet palette
Wax-coated paper palette

FINISHING
High-gloss spray varnish

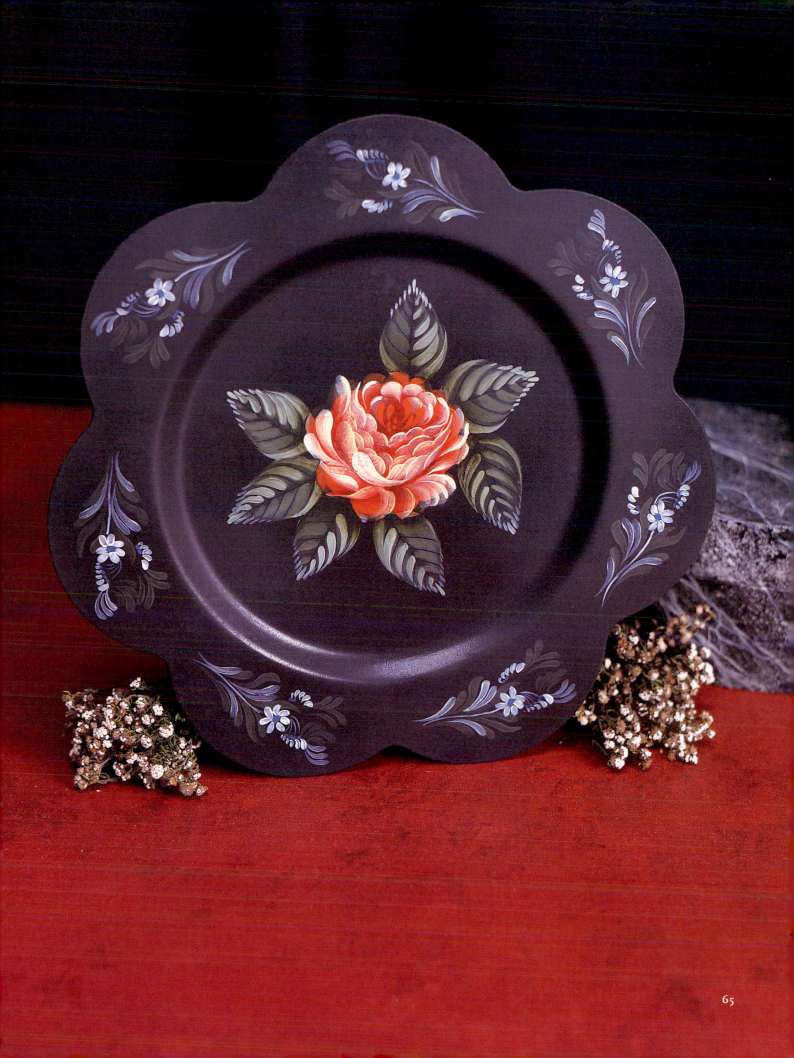

Lace-Edge Painting

GETTING READY

Clean, prime, and basecoat the tray according to the guidelines on pages 38–39. Apply two coats of basepaint with the wash brush, letting the first dry completely before applying the second. Let the paint dry overnight, or heat-cure the piece by following the instructions on page 39.

When you trace the patterns, trace only the main outlines of the center motif, omitting all of the overstrokes and other details on the rose and the leaves, and drawing lines through the center of each stroke on the nosegay to indicate its shape and position. Transfer the patterns to the tray using the chalk tracing method described on page 45.

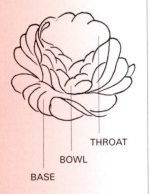

THROAT

BOWL

BASE

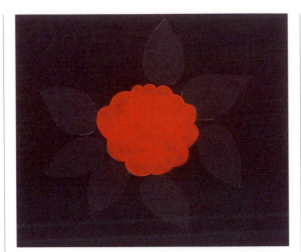

1 Use a flat brush to undercoat the rose with red light. It may be necessary to apply three coats in order to achieve opaque coverage. Be sure to allow adequate drying time between coats. Undercoat the leaves with a mixture of green umber + Prussian blue + pure black. Let the leaves dry completely before proceeding to the next step.

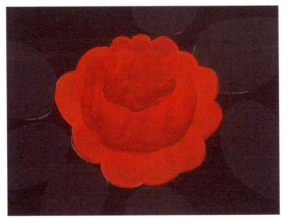

2 Coat the rose with a thin layer of gel retarder. Apply a small amount of alizarin crimson to the wet surface and work it with the flat brush until the entire rose is tinted with color. While the surface is still wet, shade the center of the throat and the bottom of the bowl with true burgundy, blending it slightly to soften the color. It will take a couple of hours for this step to dry.

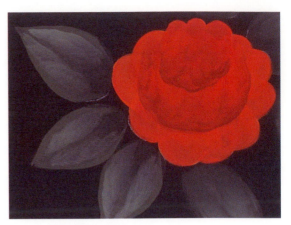

3 Use the flat brush to coat one of the leaves with gel retarder. Paint a mixture of the leaf undercoat color (see step 1) + yellow ocher into the wet surface in an oval shape on each half of the leaf, creating a midrib in the center and a shaded area around the edge. Lighten the mixture with a tad of warm white, then apply it to the oval shapes toward the tip of the leaf. Gently blend the highlights into the leaf, but avoid overblending them. Repeat this step on the remaining leaves, then let dry before proceeding.

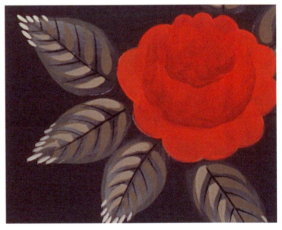

4 Again working on one leaf at a time, paint the accent strokes with the script liner brush. For the first set of comma strokes, which are made on one side of the midrib, use a mixture of green umber + yellow ocher. To make the comma strokes on the other side of the midrib, lighten the green by adding some warm white to the mixture. For the tiny lines at the tip of the leaf, use the lighter green, but pick up a touch of white on the tip of the brush before making each line. Repeat this step on the remaining leaves, then let dry. To add the thin veins between the comma strokes and along the midrib, thin some pure black with water to a flowing consistency and apply it with the script liner. Let dry.

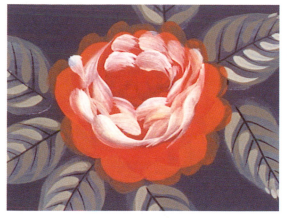

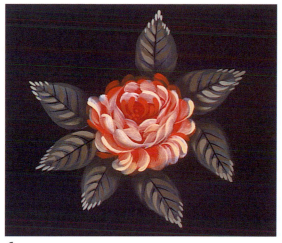

FINISHING

Finish the tray with three or four coats of varnish, letting each coat dry before applying the next.

5 Load the filbert brush with gel retarder, then stroke it into some red light. Paint loosely shaped comma stroke petals that extend beyond the rose's undercoat. This translucent layer of strokes is typical of the lace-edge painting style. Let dry.

To create the semitranslucent color you'll need for this step and the next one, lightly load the filbert brush with yellow ocher + warm white, then stroke it through some retarder. Begin by forming a couple of rows of loose comma strokes at the back of the rose's throat. Establish the bowl of the rose by making several curving comma strokes across its front. Be sure to leave spaces between strokes so that the color of the undercoat is still visible.

6 Use the filbert brush, the gel retarder, and the color that you mixed for the previous step to paint first the outer petals, then the ones along the base, with some curved comma strokes, which should follow the rose's shape and be oriented in the same direction. Let dry.

Use the script liner and the yellow ocher + warm white mixture (this time omitting the retarder) to accentuate the translucent strokes with a few small opaque comma strokes. Again using the script liner, add some small comma strokes of red light in the throat of the rose. When the rose is completely dry, shade the base of each leaf with the flat brush sideloaded with a mixture of sap green + pure black. Let dry.

7 Paint the nosegays on the rim of the tray with the script liner. Thin all of the colors with gel retarder until they are translucent. Paint the green leaves and stems, first using a mixture of green umber + Prussian blue + yellow ocher. Let dry, then use a mixture of warm white + a touch of yellow ocher to paint the white leaves, stems, and buds. Paint the center of the flower and the handle dots with a mixture of Prussian blue + a touch of green umber + warm white. Let dry overnight before varnishing.

Early Country Tin Painting

STROKE BORDERS ON A TIN CANISTER

*T*he earliest examples of American painted tinware were painted with black or asphaltum (very dark brown) backgrounds in an attempt to simulate the color and sophistication of authentic oriental lacquer. The designs of the mid- to late 1700s generally consisted of strokework borders and simple floral forms. During that period, the designs gradually became more elaborate, although the palette remained more or less the same, with the majority of the strokes painted in red, white, and yellow, often with translucent white strokes painted directly on top of the red ones.

This project features a flowing, repetitive border design that was typically painted on round tin pieces and was also commonly used to decorate document boxes. When painting this relatively simple project, strive to create attractive strokes that are consistent in size and shape. The application of the antiquing glaze mellows the entire piece, aging it gently.

WHAT YOU'LL NEED

Pattern
Page 98

Project
Round metal canister from
 Steph's Folk Art Studio
 *(see page 111 for ordering
 information)*

Supplies

SURFACE PREP
Spray-on flat-finish gray
 primer
Basecoat paint: warm white
 and pure black *(see list of
 artists' acrylics)*

TRACING AND
TRANSFERRING
Tracing paper
Fine-tip black marker
Chalk
Stylus

ARTISTS' ACRYLICS
Warm white
Turner's yellow
Yellow ocher
Naphthol crimson
Pure black

ACRYLIC MEDIUMS
Gel retarder

BRUSHES/APPLICATORS
3/4-inch wash brush
No. 12 flat brush
No. 2 script liner
2-inch glaze/varnish brush
Soft cotton cloth

BASIC PAINTING
SUPPLIES
Water container
Palette knife
Sta-Wet palette
Wax-coated paper palette
Paper towels

FINISHING
Brush-on satin-sheen
 acrylic varnish

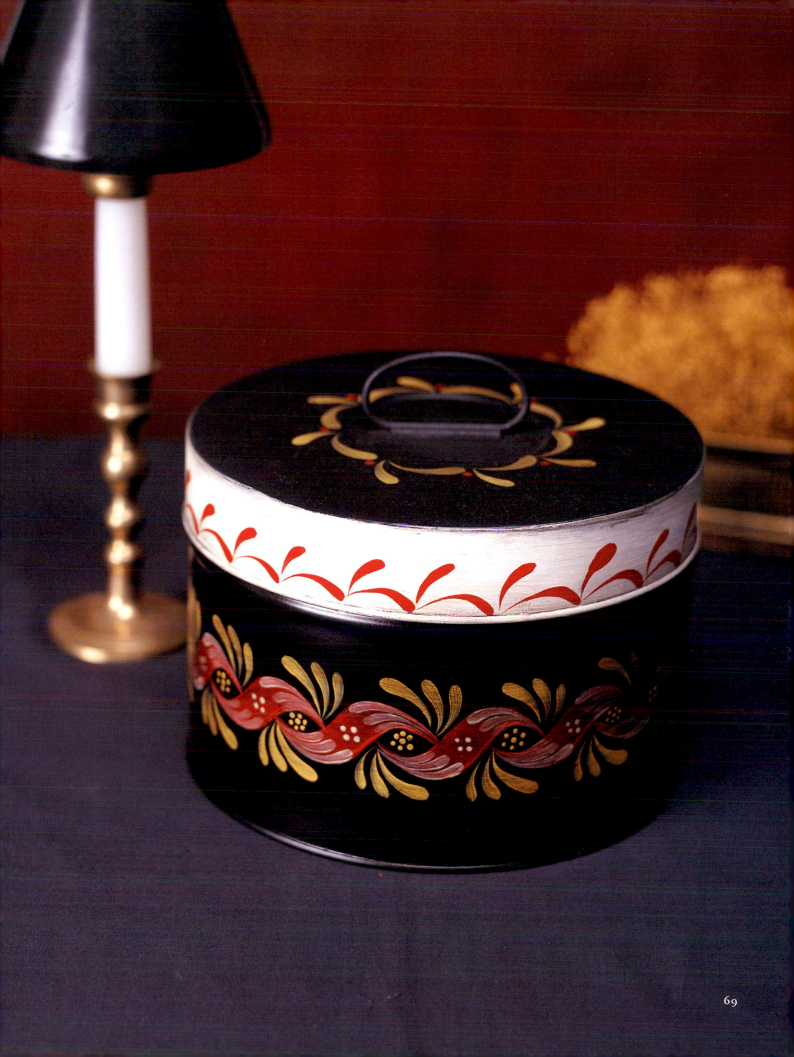

Early Country Tin Painting

GETTING READY

Following the guidelines on pages 38–39, clean, prime, and basecoat the canister, using the wash brush to basecoat the entire piece with two coats of black paint, *except* for the band on the lid between the top and the rolled lip. Let the first coat dry before applying the second.

Clean the wash brush thoroughly while the second coat of black paint is drying, then use it to paint the band on the lid of the canister with warm white. You may need to apply as many as three coats in order to achieve opaque coverage.

Trace the pattern following the instructions on page 44, then use the chalk transfer method on page 45 to transfer it to the canister. When transferring comma strokes, simply draw a line through the center of each stroke to indicate its size and position. Don't transfer the overstrokes on the large S strokes until you're ready to paint them (at the start of step 2).

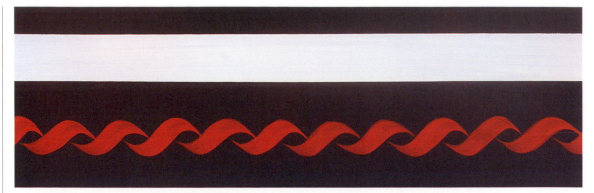

I Use the flat brush to paint the S strokes on the canister with naphthol crimson. Try to form each stroke with one fluid motion. This particular red is somewhat translucent, so it may be necessary to repaint the S strokes once they've dried. After a second coat the color should be fairly opaque, but don't be too concerned if the strokes are still somewhat translucent. Let dry.

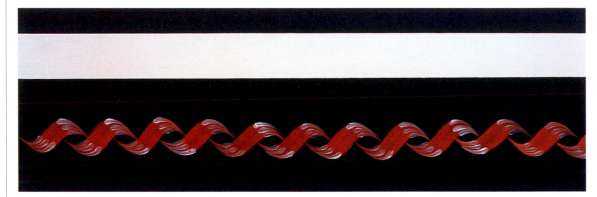

2 Create a translucent white for the comma overstrokes by combining warm white + a bit of yellow ocher, then adding an equal amount of gel retarder to the mixture. So that the paint will flow gracefully from the brush, thin the mixture slightly with water. Use this thinned white paint and the script liner to paint six comma strokes on each red S stroke. Let dry.

3 Paint the yellow comma stroke flourishes above and below the S strokes with the script liner and Turner's yellow. You can also paint the yellow strokes on the top of the lid at this point. Let dry.

FINISHING

Finish the piece with
two coats of varnish,
letting the first coat
dry before applying
the second.

4 Paint the handle dots between and on the S strokes. Use Turner's yellow to paint the dots between the strokes, and warm white to paint the dots on the strokes. Reload the handle before making each dot so that they are uniform in size. The dots on the lid of the canister are naphthol crimson. Let dry.

5 Use the script liner to paint the comma strokes on the white band with naphthol crimson. Let dry.

6 In this step, the painted decoration is antiqued with a soft black patina. Mix some pure black with an equal amount of gel retarder to create a very translucent black glaze. Pick up a little of the glaze on a soft cloth, then gently rub it over the entire red S stroke design. Refold the cloth to expose a clean area and use it to lightly buff off some of the glaze. Let dry, then repeat on the white band, then on the top of the lid.

Late Country Tin Painting

GOOSENECK COFFEEPOT WITH BALL FLOWERS

Degree of Difficulty

*A*s the production of American painted tinware continued into the 1800s, its design and palette evolved to include red and white (or ivory) backgrounds. The red pieces, which are especially coveted by collectors, were often decorated with large flowers in brown and blue and strokework in black, dark green, and yellow.

This project combines various motifs that were used throughout the manufacture of American painted tinware with a palette that is typical of its later period. The tin gooseneck coffeepot, creamer, and sugar bowl, which I unexpectedly stumbled upon while browsing for painting surfaces, are faithful reproductions of their 18th- and 19th-century prototypes. (These pieces are intended for use only as decorative objects, and cannot be used to hold or serve food.) The project instructions are specific to the coffeepot, but they can easily be adapted to the creamer and sugar bowl, whose patterns can also be found on page 99. Should you be fortunate enough to unearth already painted pieces that appear to be old but whose worth is uncertain, seek out the advice of an experienced appraiser before stripping or repainting them.

WHAT YOU'LL NEED

Patterns
Page 99

Project
Reproduction gooseneck
 coffeepot *(creamer and
 sugar bowl optional)*

Supplies

SURFACE PREP
Spray-on flat-finish gray
 primer
Basecoat paint: naphthol
 crimson *(see list of artists'
 acrylics)*

**TRACING AND
TRANSFERRING**
Tracing paper
Fine-tip black pen
Chalk
Stylus

ARTISTS' ACRYLICS
Warm white
Yellow light
Turner's yellow
Yellow ocher
Naphthol crimson
Burnt umber
Asphaltum
Pure black

ACRYLIC MEDIUMS
Gel retarder

BRUSHES/APPLICATORS
3/4-inch wash brush
No. 2 script liner
Nos. 8 and 10 flat brushes
No. 4 round brush
3/4-inch mop brush *(optional)*
1-inch glaze/varnish brush
 (optional)
Soft cotton cloth

**BASIC PAINTING
SUPPLIES**
Water container
Palette knife
Paper towels
Sta-Wet palette
Wax-coated paper palette

FINISHING
Brush-on or spray-on satin-
 sheen acrylic varnish

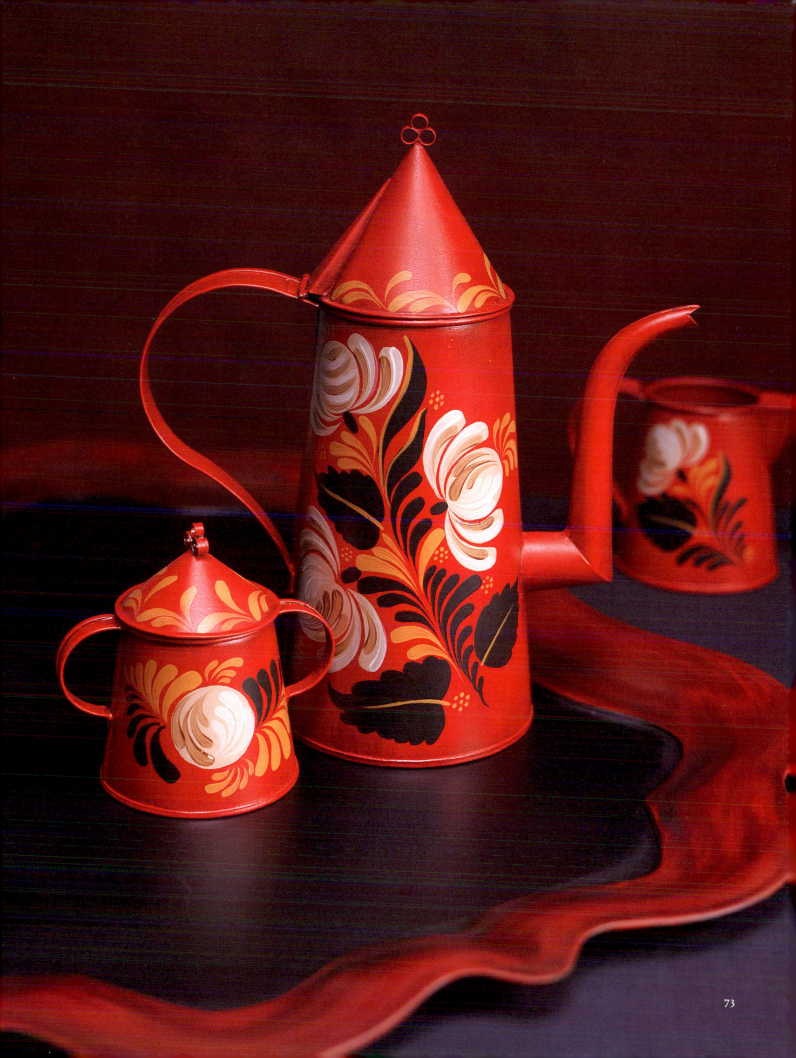

Late Country Tin Painting

GETTING READY

Clean, prime, and basecoat the coffeepot according to the instructions on pages 38–39. Use the wash brush to apply three or four coats of naphthol crimson, letting each coat dry before applying the next.

Trace, size, and transfer the pattern to the coffeepot according to the instructions on pages 44–45, using the chalk tracing transfer method.

I Undercoat the round flower shapes with a tan color mixed from warm white + asphaltum + a tad of burnt umber using the no. 8 flat brush. Use the same color to paint the large comma stroke petals on either side of them with the round brush. It may be necessary to apply more than one coat to achieve fully opaque coverage, so be sure to allow adequate drying time between coats or lifting could occur.

2 Undercoat the leaves with a dark green mixture of yellow light + pure black + a touch of naphthol crimson. Using the script liner brush, apply the outer strokes following each leaf's contours, then fill in their centers with flowing strokes. Let dry; if necessary, apply a second coat.

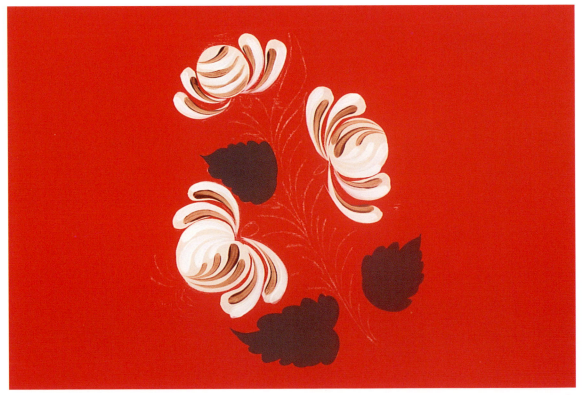

3 Use the script liner to apply the overstrokes to the flower shapes. For the light strokes, use a mixture of warm white + a bit of the tan color that was mixed for step 1. Paint the dark strokes with a dark brown combination of the tan from step 1 + burnt umber. Thin both colors with gel retarder until they are translucent.

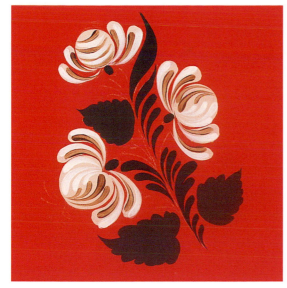

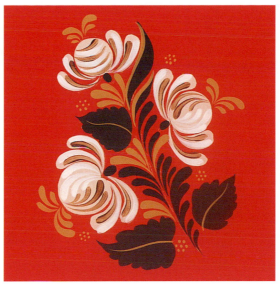

FINISHING

Finish the piece with two to three coats of varnish, letting each coat dry before applying the next.

4 Using the color that was mixed for step 2 thinned to a flowing consistency with water, paint the large green comma strokes with the script liner and the S strokes with the no. 8 flat brush. These strokes should be opaque.

5 Paint the yellow comma strokes and add the midribs to the leaves with a mixture of Turner's yellow + yellow ocher applied with the script liner.

Let the piece dry overnight, then apply one coat of varnish to protect the design during the antiquing process. Allow the varnish to dry completely before proceeding to the next step.

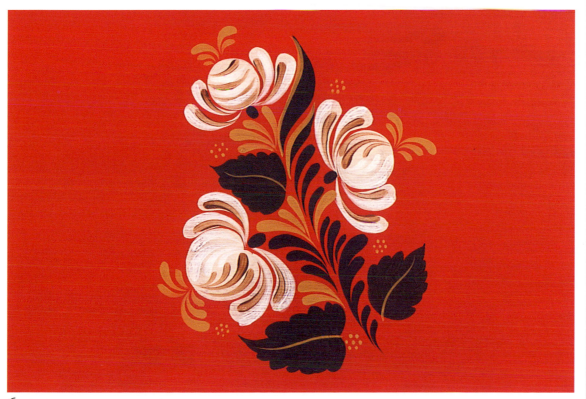

6 Rather than antiquing this piece in the traditional sense, I "mellowed" it with a very translucent pure black glaze to soften the coloration of the decorative painting. To create the glaze, mix 3 parts pure black with 10 parts gel retarder. Pick up a little of the glaze on a soft cotton cloth, then gently rub it over the surface. If desired, soften the wet glaze by brushing it with the mop brush.

Tinsel Painting

REVERSE-GLASS FLORAL STILL LIFE

*T*insel paintings were routinely begun with detailed pen-and-ink drawings that typically featured fruits, flowers, or birds. The drawings were then colored with translucent paints; by contrast, the backgrounds were painted with opaque paint, either white or black. (Although the background was traditionally painted last, I've found that by painting it first I don't have to worry as much about staying inside the pattern lines.) Tinsel paintings derive their unusual shimmer from crumpled tin foil, whose facets create a continuous play of light. Although the final result looks complex, the difficulty of this project is restricted to the lengthy waits required between some of the steps.

You can display your own tinsel painting as a framed piece of art, as an embellishment for the door of a glass-front cabinet, or as the lid of a wooden box (my choice). Because black and gold is the traditional color scheme for tinsel paintings with black backgrounds, I painted my box black and trimmed it with metallic gold. If you prefer a white background, use a soft off-white rather than a bright pure white, and frame the finished painting in a stained wooden frame, perhaps accented with gold.

WHAT YOU'LL NEED

Pattern
Page 100

Project
Octagonal wooden box with glass lid from Cabin Crafters *(see page 111 for ordering information)*

Supplies

SURFACE PREP
For the glass: rubbing alcohol, lint-free cloth, and glass and tile medium
For the box: acrylic or latex basecoat paint in black *(see list of artists' acrylics)* and metallic gold

TRACING AND TRANSFERRING
Tracing paper
Fine-tip black marker
White drawing paper
Heavy clear packing or masking tape
Technical pen or crow quill dip pen
Waterproof black ink

ARTISTS' ACRYLICS
Yellow light
Alizarin crimson
Asphaltum
Prussian blue
Dioxazine purple
Sap green
Pure black

ACRYLIC MEDIUMS
Gel retarder

BRUSHES
3/4-inch wash brush
No. 2 script liner
Nos. 8 and 10 flat brush
1-inch glaze/varnish brush

BASIC PAINTING SUPPLIES
Water container
Palette knife
Sta-Wet palette
Wax-coated paper palette
Paper towels

SPECIAL PROJECT SUPPLIES
Large piece of corrugated cardboard *(to support for the glass)*
Gloss-finish acrylic spray sealer *(for sealing the inked pattern)*
Aluminum foil
Cardboard or foamcore board *(to provide a rigid backing for the foil)*

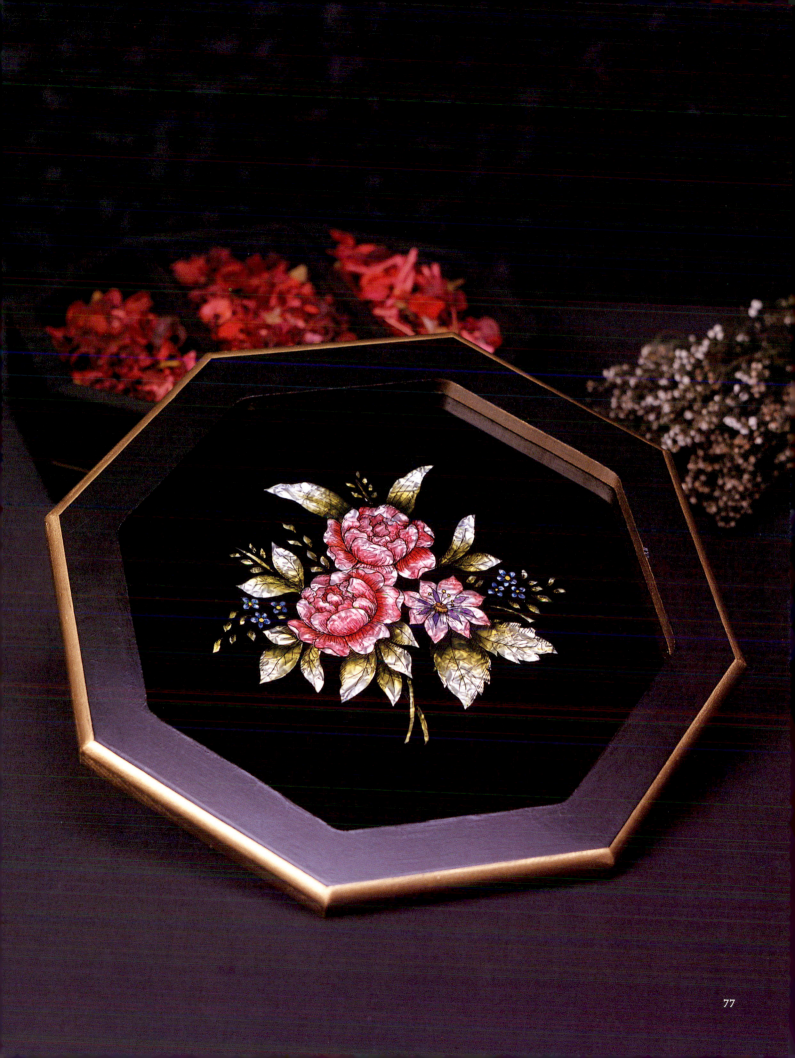

Tinsel Painting

GETTING READY

Use a fine-tip black marker to trace the main outlines of the pattern on a sheet of tracing paper. Don't trace any shading at this point, as you'll be adding it freehand later. Note that the pattern is the reverse of what is shown in the project photo on page 77. The pattern is painted in reverse so that the painting will read correctly.

Clean the back of the sheet of glass with rubbing alcohol and a lint-free cloth. Let dry, then apply a thin, even coat of glass and tile medium with the wash brush, leaving as few brush marks as possible. Let the medium cure at least overnight, but 48 hours is best, since the longer it cures, the harder and more durable it becomes. The medium will dry to a cloudy finish, but don't be concerned: By the time the painting has been completed, the cloudiness will have faded.

I Lay a large piece of cardboard on your work surface. On the cardboard, place a sheet of white drawing paper, then the traced pattern, then finally the glass, treated side up. Make sure that the pattern is centered on the height and width of the glass, then affix all three items to the cardboard by taping the edges of the glass with heavy clear packing or masking tape. Use the technical or dip pen and the black ink to carefully trace the pattern on the glass. Once you've made sure that your tracing is complete, remove the paper tracing from beneath the glass, then tape the glass and the white paper to the cardboard once again. (Removing the paper tracing makes it easier to add the shading in the next step so that you can see exactly how the drawing is developing.)

2 Again working in pen and ink, shade the pattern on the glass. Either use the pattern on page 100 as your guide, or shade it to suit your own taste. Let the ink dry for several hours.

Even though the ink is waterproof, the pattern will either smear or dissolve when paints are applied to it because it is on glass, so it must be sealed first. Apply three or four coats of spray sealer, letting each coat dry before applying the next, to ensure that the entire surface—not just the pattern—has been completely sealed. Allow at least 4 hours to elapse before proceeding.

3 Load the script liner with pure black, then use it to apply the paint around the smallest elements of the pattern. If you mistakenly paint inside any of the motifs, just wipe it away with a damp brush while it's still wet. When you've filled in all of the areas immediately surrounding the motifs, use a flat brush to paint the rest of the glass. Let the first coat dry, then apply a second. The background will look uneven when viewed from the back, but when you remove the glass from the cardboard and turn it over so you can see whether any areas were left unpainted, it will appear smooth and opaque. Make sure that the second coat is completely dry before you begin painting the motifs.

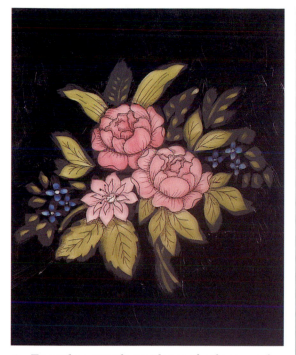

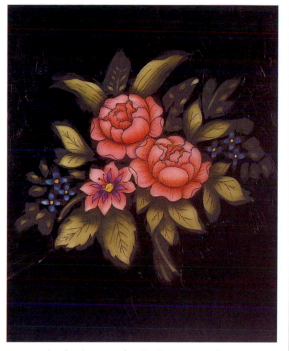

4 To apply a translucent layer of color to each motif, mix each of the following colors with gel retarder, using a ratio of 1 part paint to 2 parts retarder. Paint the roses and the passionflower with alizarin crimson, the smaller blossoms with Prussian blue, and the leaves with a mixture of sap green + a touch of pure black. Let this layer of paint dry completely before moving on to the next step; if you don't, it will start to lift away from the surface, possibly pulling the glaze and the inked drawing along with it—a problem that is virtually impossible to repair.

5 To shade the motifs, doubleload a flat brush with gel retarder and the appropriate color. Use a mixture of alizarin crimson + asphaltum for the roses and the passionflower, a mixture of sap green + pure black + a touch of Prussian blue for the leaves, and a mixture of Prussian blue + a touch of pure black for the small blossoms.

When the shading is dry, accent the passionflower petals with dioxazine purple, then paint its center and the centers of the small blossoms with yellow light. Check the color by placing the glass painted side down over a piece of crumpled aluminum foil that's been slightly smoothed out. If necessary, intensify the color by adding another layer of translucent paint. Let dry.

FRAMING

Place the finished tinsel painting over the crumpled aluminum foil. Decide whether you prefer the foil's shiny or dull side. In order to hold the foil and the glass together, the tinsel painting must be framed. Place the glass in the frame so that the painted side faces toward the back, then place the foil on top of the painting. Put a rigid backing such as cardboard or foamcore board over the foil and secure it in the frame.

Theorem Painting

CHERRIES THEOREM IN A FAUX BURL FRAME

*T*he most popular theorem painting subjects were fruits, flowers, and landscapes, which were usually stenciled with oil paints on white or off-white velvet. (Watercolor paints and paper were less commonly used.) Instead of a brush, the standard paint applicator was a finger wrapped in a piece of velvet, which permitted only small amounts of paint to be deposited on the surface, thus ensuring a delicate image. One of the wonderful things about the original theorem paintings is that they are arguably lovelier today, as the passage of time has softened the colors and mellowed the velvet with a tawny patina.

Simple but charming, this project is designed to serve as an introduction to theorem painting that will produce an attractive result, even for a beginner. Cutting the stencils requires forethought and accuracy, but "painting" the theorem is easy and enjoyable. In areas that are light in value, very little paint, or none at all, is applied—the white of the velvet provides the highlights—while in shaded areas, the paint is applied more heavily, or darker colors are used. As a finishing touch, the theorem is "aged" with a "tea stain"—actually asphaltum paint thinned with textile medium and water.

WHAT YOU'LL NEED

Stencils
Pages 101–102

Project/Painting Surface
1 yard of off-white velvet or
 velveteen *(includes extra
 for scrap)*
Wooden frame from Hy-Jo
 Manufacturing Imports
 Corp. *(see page 111 for
 ordering information)*

Supplies

SURFACE PREP
For the theorem: corrugated
 cardboard *(cut to fit into the
 frame)* and spray adhesive
For the frame: #220-grit sand-
 paper, tack rag, and naph-
 thol crimson basepaint *(see
 list of artists' acrylics)*

CUTTING THE STENCILS
Tracing paper
Fine-tip black marker
Four sheets of acetate OR
 Mylar
Stencil burner
Piece of glass
Masking tape

ARTISTS' ACRYLICS
Naphthol crimson
True burgundy
Asphaltum
Burnt umber
Green umber
Sap green
Pure black

ACRYLIC MEDIUMS
Textile medium
Glazing Medium

BRUSHES/APPLICATORS
Three no. 8 OR no. 14 stencil
 brushes *(one for each
 color or color family)*
No. 2 script liner
No. 8 OR 10 flat brush
1-inch glaze/varnish brush
Natural sea sponge

**BASIC PAINTING
SUPPLIES**
Water container
Palette knife
Sta-Wet palette
Wax-coated paper palette
Paper towels

FINISHING
Brush-on satin-sheen
 acrylic varnish

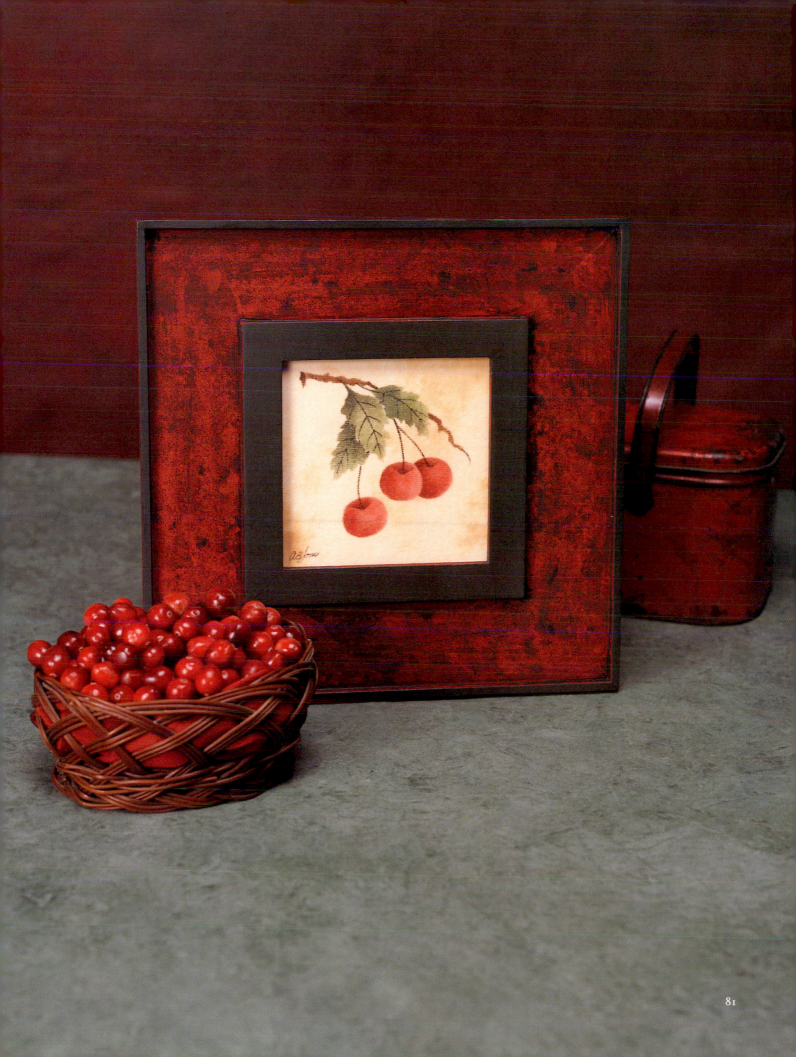

Theorem Painting

GETTING READY

Trace and cut the stencils according to the instructions on pages 46–47.

Attach a square of velvet to the corrugated cardboard with spray adhesive. Don't apply too much adhesive to the back of the velvet; use only enough to attach it firmly to the cardboard.

WORKING WITH STENCIL BRUSHES

To load a stencil brush, dip the bristles into textile medium, dab them into the paint, then swirl them on a paper towel to remove almost all of the color. ALWAYS test a newly loaded brush on a piece of scrap velvet before you apply any paint to the theorem. If the color is deposited faintly but uniformly, the brush is ready for stenciling. Use a separate brush for each color or color family (reserve one brush for use with reds, one for greens, and so on), and do NOT wash or wet the brushes while you're working.

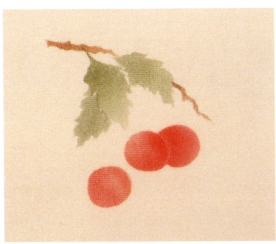

1 In this step, the local colors (medium values) are applied to the cutouts on each stencil. Place Stencil 1 in the center of the velvet and secure it at each corner with a small piece of masking tape. Paint the cherries with naphthol crimson and the leaves with sap green. Repeat with Stencils 2, 3, and 4. On Stencils 3 and 4, apply burnt umber only to the branches; do *not* apply paint to the indentation at the top of each cherry.

2 In this step and the next, the cutouts are shaded with darker values or colors. Place Stencil 1 on the velvet and shade the two leaves with green umber where the center leaf overlaps them, then shade the cherry with true burgundy. On Stencil 2, use the same colors to shade the base of the leaf and the righthand side of each cherry. On Stencil 3, shade the branch on either side of the leaf with a stronger application of burnt umber. Return Stencil 1 to the velvet and deepen the shading on the lefthand side of the cherry with a mixture of true burgundy + a bit of sap green.

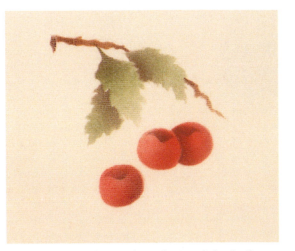

3 Place Stencil 3 on the velvet and shade the indentations on the cherries with a mixture of true burgundy + sap green. Repeat with the cherry on Stencil 4, then shade the cut end of the stem with a fairly heavy application of burnt umber.

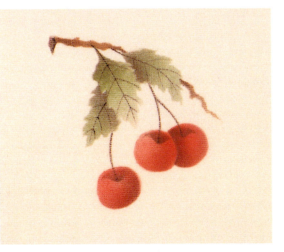

4 In this step, the details of the composition are painted with the script liner and paint that has been thinned to a flowing consistency with water and textile medium. Before you try to paint the theorem, test the consistency of the paint on a scrap piece of velvet: If it's too thin, it will bleed and run; if it's too thick, it won't flow off the brush.

Paint the veins on the leaves with pure black, then paint the stems with a mixture of green umber + burnt umber. Let this step dry for several hours before proceeding.

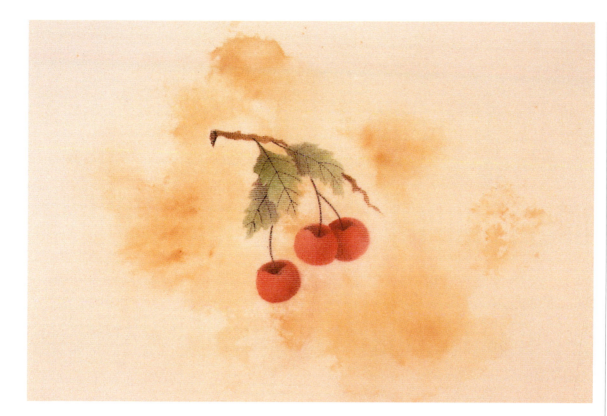

Apply two coats of varnish to the frame, letting the first coat dry before applying the second. Attach the theorem to a rigid backing (either the cardboard you used during stenciling or a piece of foamcore board) and frame it under glass.

5 Remove the velvet from the cardboard backing and dampen the area that will be framed with cool, clean water by dabbing it with a wet paper towel. While the velvet is still wet, mix a little asphaltum with some textile medium, then thin the mixture with water until it is soupy and very translucent. Dip a wet paper towel into the thinned paint, then dab it on the velvet, *slightly* more heavily in some areas, to create a natural-looking stain that overall is barely visible. If the paint doesn't flow over the surface of the velvet, dampen the velvet again. When you're satisfied with the results, allow the velvet to dry completely.

6 Following the instructions on page 41, sand and tack the frame, then basecoat it with naphthol crimson. Let dry. Brush on a mixture of burnt umber + pure black thinned with Glazing Medium. To create the mottled faux burl, dab the wet glaze with a dampened sea sponge. Let the glaze dry, then paint the trim with green umber.

Bronzing

BRONZED METAL TRAY WITH STORMONT WORK

Degree of Difficulty

*B*ronzing is the decoration of surfaces with metallic powders, which traditionally were applied to a tacky coat of wet varnish, typically over dark grounds. When bronzing was first developed, the powders were applied freehand with a brush, a procedure that required considerable skill. Later, the manufacture of bronzed objects was accelerated when stencils were incorporated into the technique, as they allowed virtually anyone to create beautiful, lustrous designs.

Bronzing powders, which consist of extremely fine particles of metal, are still used today, but the health risks associated with them motivated me to search for a safer alternative. I found that metallic waxes yield similar results, but without the hazards of working with powdered metals or pigments. For this project, I skipped the traditional tacky coat of varnish, and created subtle shading and highlights within the stenciled print by using three shades of gold wax. The process of stenciling is relatively easy (see page 47 for an overview), but cutting the stencils requires time and patience. To complement the bronzing, I finished the edge of the tray with a thin, undulating line of gold known as Stormont work, a rather laborious leafing technique that I've simplified here by using a metallic paint marker.

WHAT YOU'LL NEED

Stencils
Pages 103–108

Project
Rectangular Chippendale
 metal tray from Barb
 Watson's Brushworks
 *(see page 111 for ordering
 information)*

Supplies

SURFACE PREP
Spray-on flat-finish gray
 primer
Basecoat paint: pure black
 (see list of artists' acrylics)

CUTTING THE STENCILS
Tracing paper
Fine-tip black marker
Five sheets of acetate or Mylar
Stencil burner
Piece of glass
Masking tape

ARTISTS' ACRYLICS
Pure black

**TREASURE GOLD
METALLIC WAXES**
Florentine gold
Brass
Classic gold

BRUSHES
3/4-inch wash brush
Three no. 8 OR no. 14 stencil
 brushes *(one for each
 color of wax)*
No. 2 script liner

OTHER SUPPLIES
Paper towels
Metallic gold paint pen

FINISHING
Gloss-finish acrylic spray
 sealer

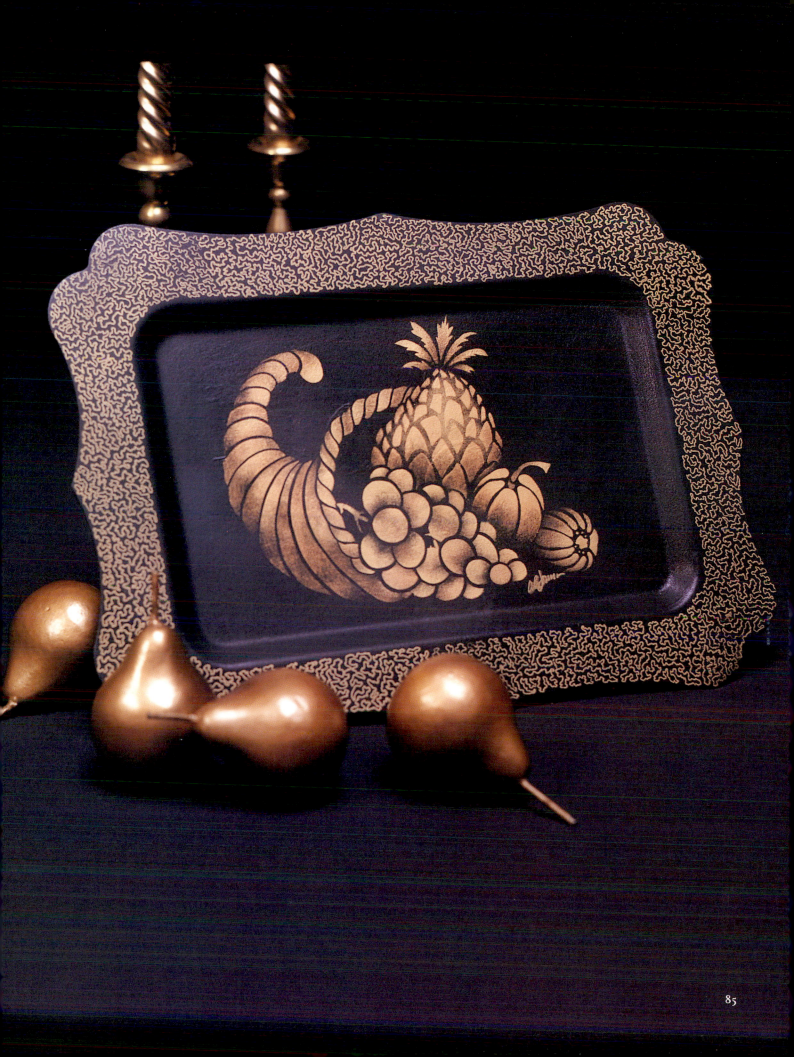

Bronzing

GETTING READY

Clean, prime, and basecoat the tray according to the instructions on pages 38–39. Apply as many coats of black paint as necessary to achieve smooth, opaque coverage, letting each coat dry before applying the next.

Trace and cut the stencils according to the instructions on pages 46–47.

I Place Stencil 1 in the center of the tray and secure its edges with small pieces of masking tape. Dip one of the stencil brushes into the Florentine gold wax (a dark value), then swirl the bristles on a folded paper towel to distribute the color in the brush and remove the excess. (Do this each time you load the brush.) Using a gentle circular motion, lightly apply the wax to the cutouts in the stencil. As you work, concentrate the color in the center of each motif.

2 Remove Stencil 1, then secure Stencil 2 on the tray with tape. Using the technique described in step 1, apply Florentine gold to all of the cutouts. When working on the stemmed melon, apply the wax more heavily near the stem than at the bottom, where the gold should fade to black. The color on each grape should be stronger around the edges than it is in the center.

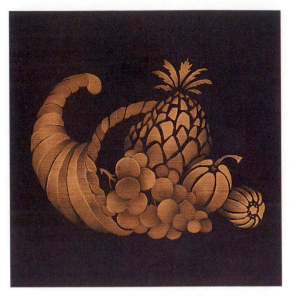

3 Remove Stencil 2 from the surface. Following the procedure described above and again using Florentine gold, stencil the cutouts in Stencils 3, 4, and 5. When working on Stencil 3, concentrate the color for the pineapple in the central cutouts.

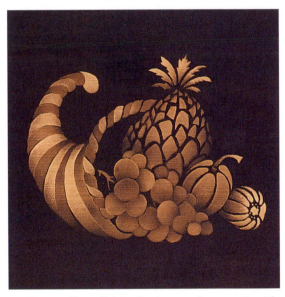

4 Return Stencil 1 to the tray and secure it with tape. Dip a clean, dry stencil brush into the classic gold wax (a medium value) and swirl the bristles on a paper towel. Add highlights to the center of each section of the cornucopia's "horn," the right side of the melon, the top of the pineapple's leaf, and a few sections of the cornucopia's rim.

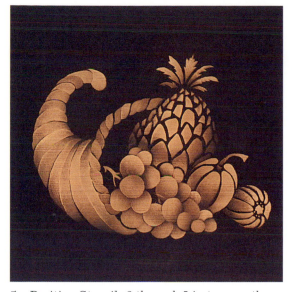

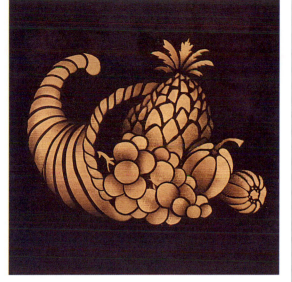

FINISHING

Finish the tray with
three or four coats of
acrylic spray sealer.

5 Position Stencils 2 through 5 in turn on the
tray and apply classic gold wax to the cutouts on
each. On Stencil 2, focus the application on the
center of each section of the cornucopia's horn,
the stem end of the melon, and the outside edges
of each grape. On Stencil 3, highlight the cutouts
at the center of the pineapple and the edges of
each grape. On Stencils 4 and 5, highlight the
outside edge of each grape and the grape stems.

7 Chances are that the print isn't as neat as
you'd like it to be—this was certainly the case on
my tray—so use the script liner brush and some
pure black to cover any extraneous gold wax.
I also decided to paint separations among the
grapes and between the sections of the cornu-
copia horn and rim. Let the paint dry thoroughly.

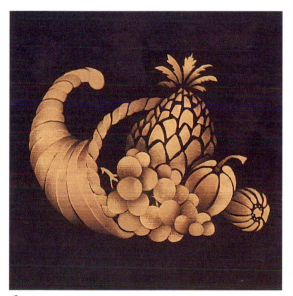

6 Apply the brass color (the lightest value)
wherever you want the brightest highlights on
a particular motif. Continue to concentrate the
color where you've been doing so all along, using
the finished example on page 85 as a guide. After
you've added highlights to all five stencils, eval-
uate your work to see if any areas need addition-
al highlighting. Once you're satisfied with the
piece, let it dry for several hours.

8 Use the metallic gold paint pen to draw the
Stormont work on the rim of the tray. The tech-
nique may be named for a 16th-century English
statesman whose speeches tended to meander,
gradually wandering from the original point.
Keep this bit of folklore in mind as you work:
Simply pick a starting point, then form a wavy,
undulating squiggle that turns back on itself—
but never crosses itself—resulting in a dense, ran-
dom design. Apply this squiggle around the entire
rim until you reach the starting point again.

The Peter Hunt Style
HEARTS AND BALL FLOWERS ON A WOODEN CANISTER

Degree of Difficulty

*V*irtually all of Peter Hunt's designs are based on the round brush comma stroke (page 28), or the "basic stroke," as he called it; he believed that anyone could learn his style of painting if they were able to master this stroke. Hunt drew inspiration from many different styles of folk art, including traditional country tin painting. (Ball flowers also figure prominently in the Late Country Tin Painting project shown on pages 72–75.) He painted exclusively with Du Pont enamel oil-based housepaints, almost always "glazing" or antiquing his designs with either "turkey umber" (raw umber) or black.

When you paint a piece in Peter Hunt's style, take a lighthearted approach, bearing in mind that not every stroke needs to be—or even should be—perfect. Consequently, this project requires only a basic level of brushstroke skills. I love the look of the heavy antiquing and the feeling of warmth that it brings to pieces. Once you've painted a project in this charming, "primitive" style, I'm sure you'll want to paint many more!

WHAT YOU'LL NEED

Pattern
Page 109

Project
Double-lidded wooden box
 from PCM Studios *(see
 page 111 for ordering
 information)*

Supplies

SURFACE PREP
#220-grit sandpaper
Tack rag
Basecoat paints: damask blue
 *(bright, light-to-medium
 value blue acrylic or latex)*
 and naphthol crimson *(see
 list of artists' acrylics)*

**TRACING AND
TRANSFERRING**
Tracing paper
Fine-tip black marker
White chalk
Stylus

ARTISTS' ACRYLICS
Yellow light
Turner's yellow
Naphthol crimson
Brilliant ultramarine
Payne's gray
Pure black

ACRYLIC MEDIUMS
Gel retarder
Glazing Medium

BRUSHES
3/4-inch wash brush
No. 10 flat brush
No. 2 script liner
No. 4 round brush *(optional)*
3/4-inch mop brush *(optional)*
1-inch glaze/varnish brush

**BASIC PAINTING
SUPPLIES**
Water container
Palette knife
Sta-Wet palette
Wax-coated paper palette
Paper towels
Cotton rags

FINISHING
Brush-on satin-sheen
 acrylic varnish

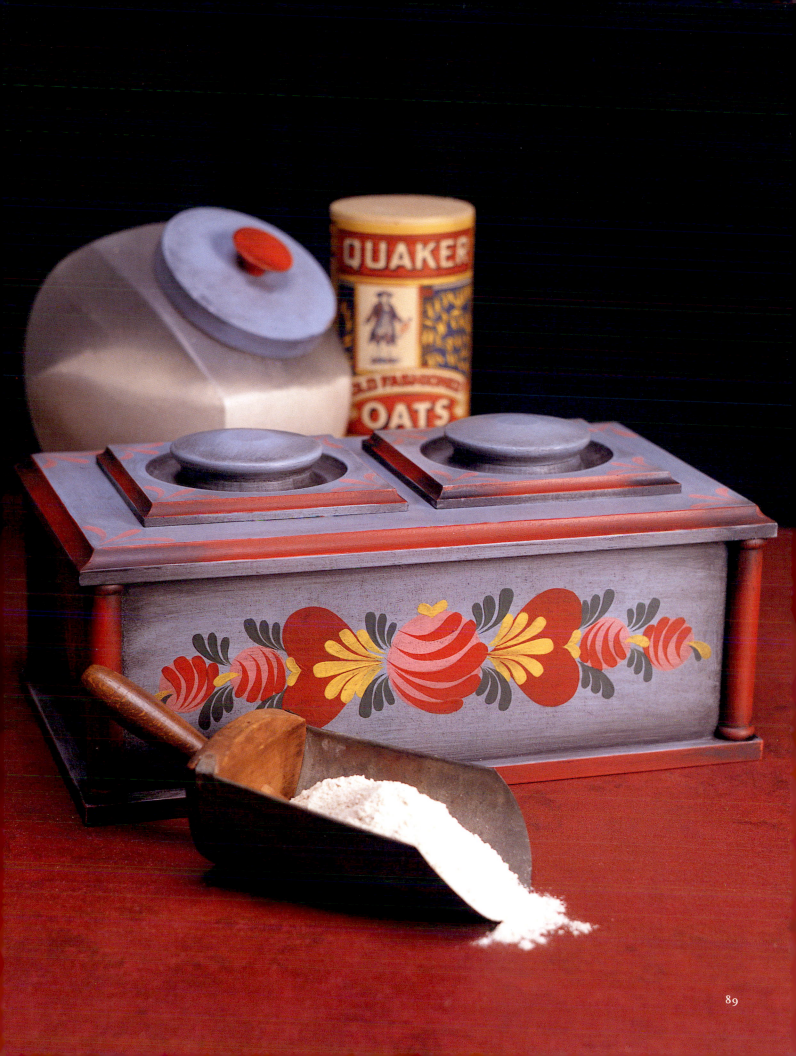

The Peter Hunt Style

GETTING READY

Sand, tack, and basecoat the box according to the instructions on page 41. Use the wash brush to basecoat the entire box with damask blue. Let the first coat dry, then apply a second. Once the second coat has dried, use the flat brush to paint selected areas with naphthol crimson. In order to cover the blue completely, you'll need to apply at least two coats. Be sure to allow adequate drying time between coats. Let the box dry completely before transferring the design to the surface.

Trace the pattern following the instructions on page 44. At this point, you need only transfer the outlines of the roses (the ball flowers) and the hearts; transfer the overstrokes just prior to painting them. When transferring the strokes, simply draw a line through the center of each one to indicate its size and position.

I Use the flat brush to undercoat the hearts with naphthol crimson and the ball flowers with a pink mixture of titanium white + naphthol crimson. If necessary, apply a second coat so that the undercoat is completely uniform and opaque, but be sure to allow adequate drying time before doing so.

2 Apply the comma overstrokes to the ball flowers using the script liner fully loaded with naphthol crimson. Let dry.

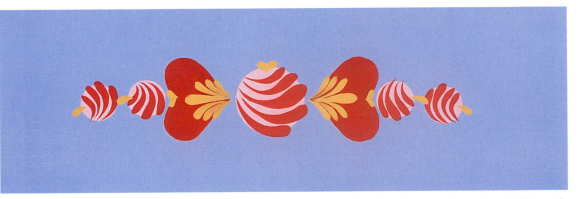

3 Use the script liner to paint the comma strokes on the hearts with a mixture of equal parts Turner's yellow and yellow light. Use this same mixture to add the small comma stroke hearts at the top of each large heart and the center ball flower, and the small comma strokes next to each of the small ball flowers. Let dry.

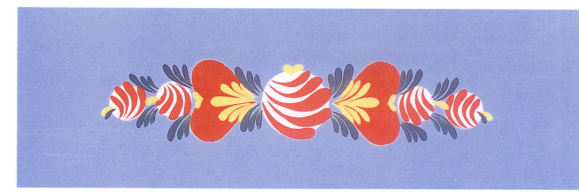

FINISHING

Apply two coats of varnish, letting the first coat dry before applying the second.

4 Paint the trios of green comma strokes using a mixture of brilliant ultramarine + yellow light applied with either the script liner or the round brush. Work trio by trio, starting with the largest stroke in each, then progressing to the medium and then the smallest.

Paint the comma strokes that trim the top of the box using the script liner fully loaded with the pink that was mixed for the ball flowers in step 1. Refer to the photo of the finished project on page 89 for size and placement.

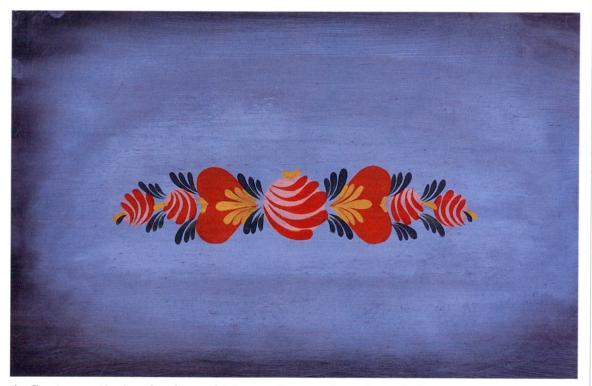

5 Create an antiquing glaze by combining equal parts gel retarder and Glazing Medium, then adding some Payne's gray and a bit of pure black to the mixture. Working on one surface at a time, apply the glaze to the box with the wash brush, then wipe it off with the cotton rag. If the glaze is difficult to remove, dampen the rag with water, then continue rubbing. Remove most of the glaze to expose the painted design and to simulate wear in those areas where the box would normally be handled, and leave the glaze a little heavier surrounding the design and within any crevices. If desired, use the mop brush to soften the remaining glaze. (For an authentic Peter Hunt look, remove the glaze sparingly, then soften it only slightly so that it looks somewhat coarse.) Let dry.

The Peter Ompir Style

WOODEN GRANNY BUCKET WITH STROKE BORDERS AND FRUITS

Degree of Difficulty

*O*mpir's work regularly featured fruits, flowers, and characters dressed in Colonial costume—all standard decorative painting fare, but his intelligent use of color and felicitous designs give each piece he decorated tremendous appeal. The granny bucket in this project is typical of the objects he decorated, and the pattern and palette are certainly in keeping with his look. Ompir's paintings may seem simple to the casual observer, but the techniques he used for shading (sideloading) and highlighting (rapid wet-in-wet blending) require superior brush-handling skills. Instead of seamlessly blending several colors or values, the Ompir style keeps them distinct by barely merging them. To perfect the mellow look of his designs, he developed a complex method of antiquing that imparted a subtle richness. Although my simplified antiquing technique by no means replicates Ompir's exquisite shading, it lends a charming "Ompir quality" to the piece.

WHAT YOU'LL NEED

Pattern
Page 110

Project
Wooden bucket from Boulder Hill Woodworks *(see page 111 for ordering information)*

Supplies

SURFACE PREP
Primer
#400-grit sandpaper
Tack cloth
Basecoat paint: chamois *(light, bright yellow-brown acrylic or latex)* and naphthol crimson *(see list of artists' acrylics)*

TRACING AND TRANSFERRING
Tracing paper
Fine-tip black marker
Gray transfer paper
Stylus

ARTISTS' ACRYLICS
Titanium white
Yellow light
Medium yellow
Turner's yellow
Yellow ocher
Pure orange
Red light
Naphthol crimson
Burnt carmine
Burnt umber
Hauser green light
Hauser green medium
Green umber
Pure black

ACRYLIC MEDIUMS
Gel retarder

BRUSHES
Nos. 8, 10, and 12 flat brushes
No. 2 script liner
3/4-inch wash brush
2-inch glaze/varnish brush

BASIC PAINTING SUPPLIES
Water container
Palette knife
Wax-coated paper palette
Sta-Wet palette
Paper towels

ANTIQUING SUPPLIES
Dishwashing liquid
#0000 steel wool
Paints: burnt umber and pure black *(see list of artists' acrylics)*

FINISHING
Brush-on satin-sheen acrylic varnish

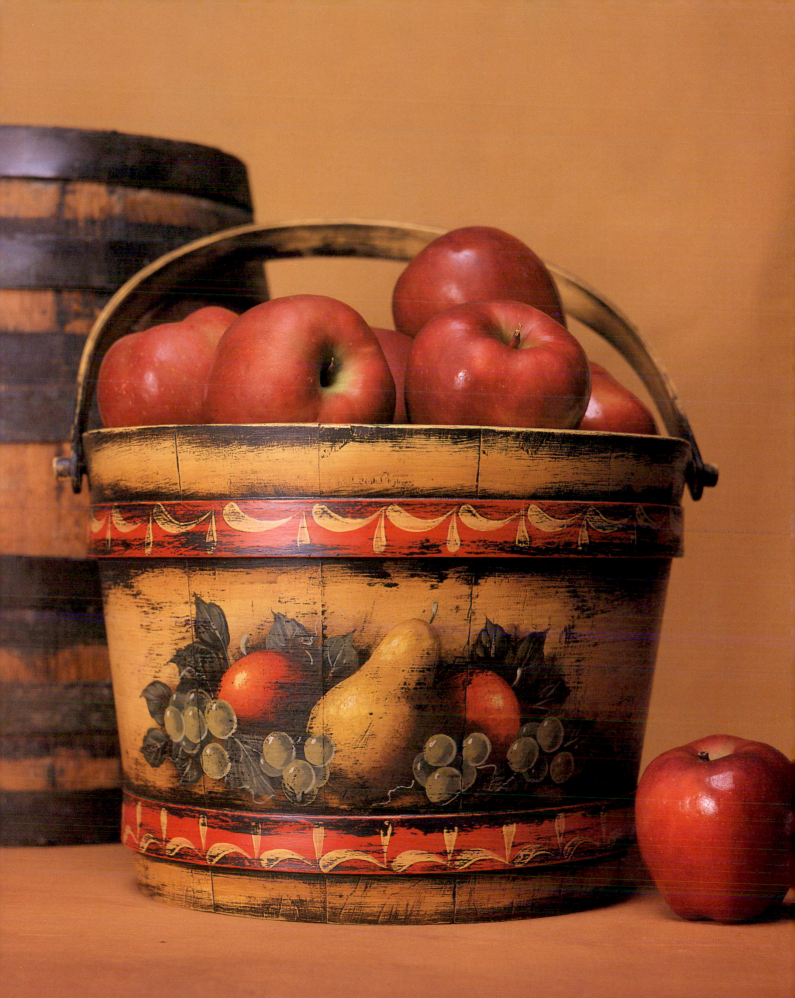

The Peter Ompir Style

GETTING READY

Prime, sand, tack, and basecoat the bucket according to the instructions on pages 40–41. Apply two coats of base-paint, allowing adequate drying time between coats. Trim the bands with naphthol crimson, then let dry.

Following the instructions on page 44, trace the pattern, then transfer it to the surface using the transfer paper method described on page 45.

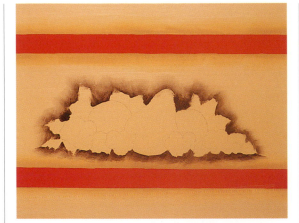

1 In this project, the antiquing process begins *before* the pattern is painted. Using a wash brush doubleloaded with gel retarder and yellow ocher, apply color along the top and bottom of each red band. Rinse the brush thoroughly, then doubleload it with retarder and a mixture of burnt umber + pure black. Pat the color around the edges of the pattern so that it gradually fades away from it. Be sure to apply this color along the bottom of the pattern as well. Let this appli-cation dry before you begin painting.

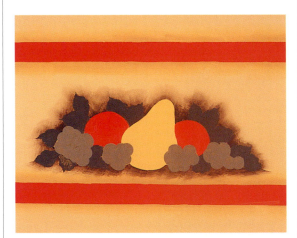

2 Undercoat the motifs using the largest flat brush that will fit comfortably into each area. Apply two coats if necessary, letting the first dry before applying the second. For the leaves, use green umber; for the apples, naphthol crimson; for the pear, Turner's yellow; and for the grapes, Hauser green medium.

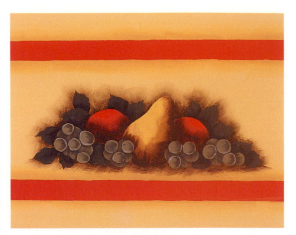

3 Shade the motifs by sideloading the largest flat brush you can comfortably maneuver within any given area, then applying the color wherever one element appears in front of another. Use pure black to shade the leaves, burnt carmine for the apples, and green umber for the grapes. Shade the pear by first applying yellow ocher to half its width, letting it dry, then applying burnt umber over the half the yellow ocher layer.

4 Highlight the tops of the apples and the leaves by applying several layers of progressively lighter colors, then very gently blending them together. Begin by applying a broad stroke or area of one color with the largest flat brush you can manage within a given area, then apply the next partially within it, gently blending the edge of the second color. Repeat this technique for each remaining color. You must work quickly because you're working against the short drying time of the paint.

Highlight the apples with the following series of colors: naphthol crimson, red light, pure orange, yellow light + titanium white, ending with a little pure titanium white for the peak of the highlight. Highlight the leaves with strokes of Hauser green light.

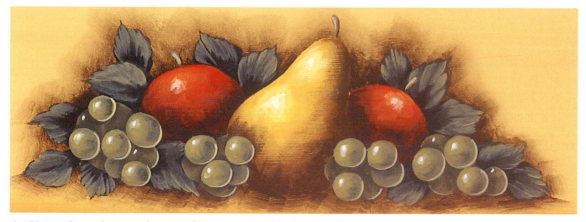

FINISHING

Apply two coats of varnish, letting the first coat dry completely before applying the second.

5 Using the technique described in step 4, highlight the left side of the pear with yellow medium, yellow light, yellow light + titanium white, and finally titanium white. For the grapes, highlight their left side with Hauser green medium, Hauser green light, and Hauser green light + titanium white, then apply titanium white with a liner brush for the final highlight.

Once the highlights are completely dry, apply three coats of satin-sheen varnish to protect it during the antiquing process, letting each coat dry before applying the next. Let the last coat of varnish dry overnight.

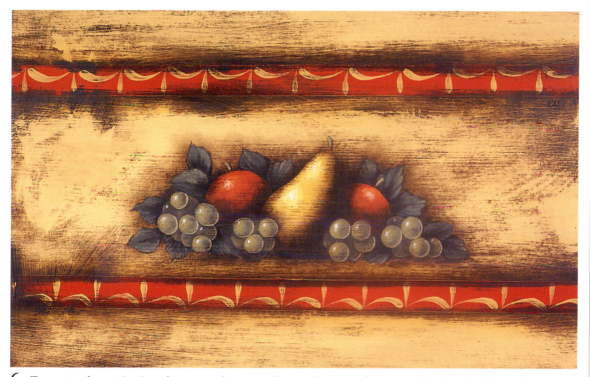

6 To create the antiquing slurry, combine equal parts burnt umber, pure black, and dishwashing liquid, then mix with the palette knife. Add a little water so that the mixture flows smoothly. When you brush on the slurry, it will cover the painting completely. Since this is a messy process, get it over with by antiquing the entire bucket at once. Let the slurry dry for about an hour, or until it has lost its sheen, at which point it should be dry to the touch.

Starting in the center of the bucket and working outward, rub the surface with the steel wool. If the antiquing is difficult to remove, wipe the surface with a wet paper towel, then continue rubbing with the steel wool. You can remove as much or as little of the antiquing as you like. You can remove it from highlighted areas and leave it almost intact over shaded ones, or you can remove it nearly all of it from the painting itself, then leave it heavy immediately surrounding the design before creating a gradual fade. If you don't like the result, remove all of it (except what lies within crevices or recessed areas), then repeat this step. Let the antiquing dry overnight.

Patterns and Stencils

FRAKTUR PAINTING

Project instructions are on pages 56–59. Use the tracing at same size. See pages 44–45 for detailed instructions on tracing and transferring patterns.

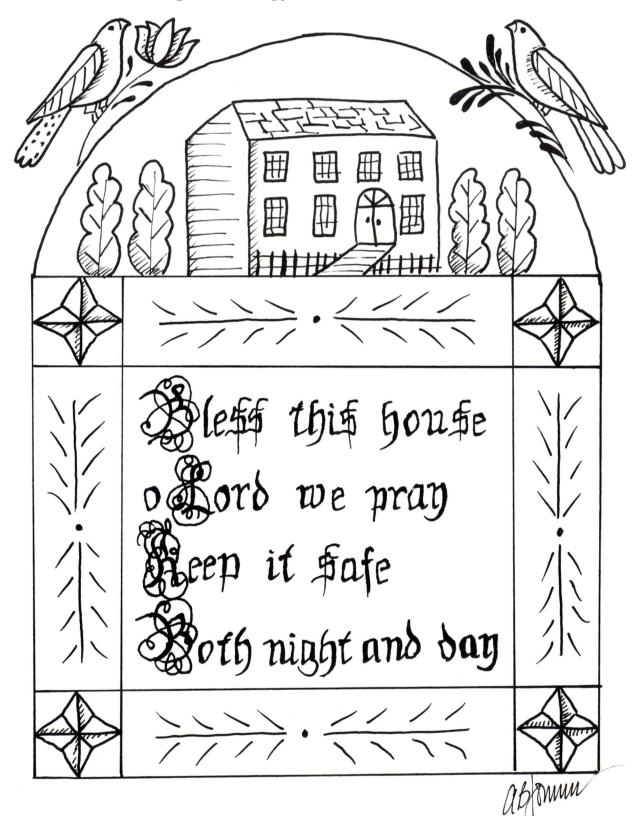

Bless this house
o Lord we pray
Keep it safe
Both night and day

PENNSYLVANIA-DUTCH MOTIFS

Project instructions are on pages 60–63. Enlarge the tracing at 110%. See pages 44–45 for detailed instructions on tracing, sizing, and transferring patterns.

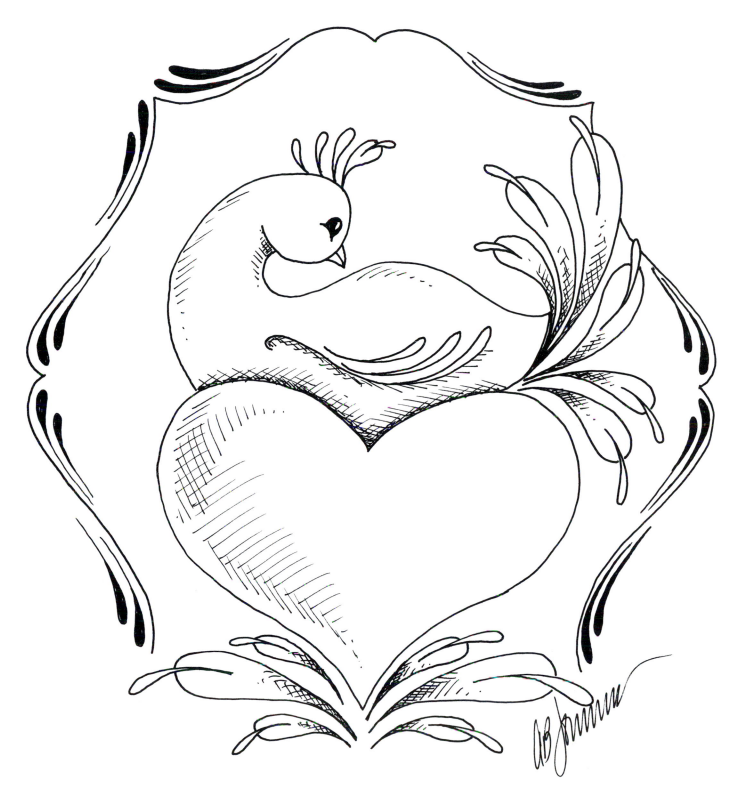

LACE-EDGE PAINTING

Project instructions are on pages 64–67. Use the tracings at same size. See pages 44–45 for detailed instructions on tracing and transferring patterns.

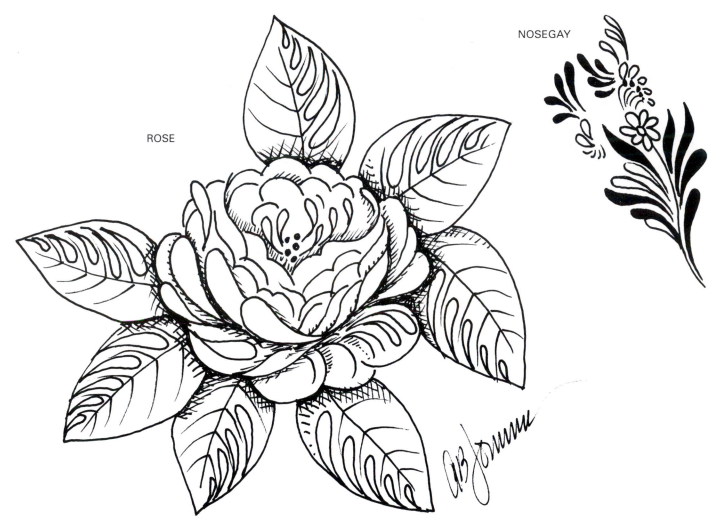

NOSEGAY

ROSE

EARLY COUNTRY TIN PAINTING

Project instructions are on pages 68–71. Use the tracing at same size. (To repeat the pattern around the canister, transfer the pattern, then overlap a set of dashed lines over one end of the transfer.) See pages 44–45 for detailed instructions on tracing and transferring patterns.

LATE COUNTRY TIN PAINTING

Project instructions are on pages 72–75. Enlarge the tracings at 110%. See pages 44–45 for detailed instructions on tracing, sizing, and transferring patterns.

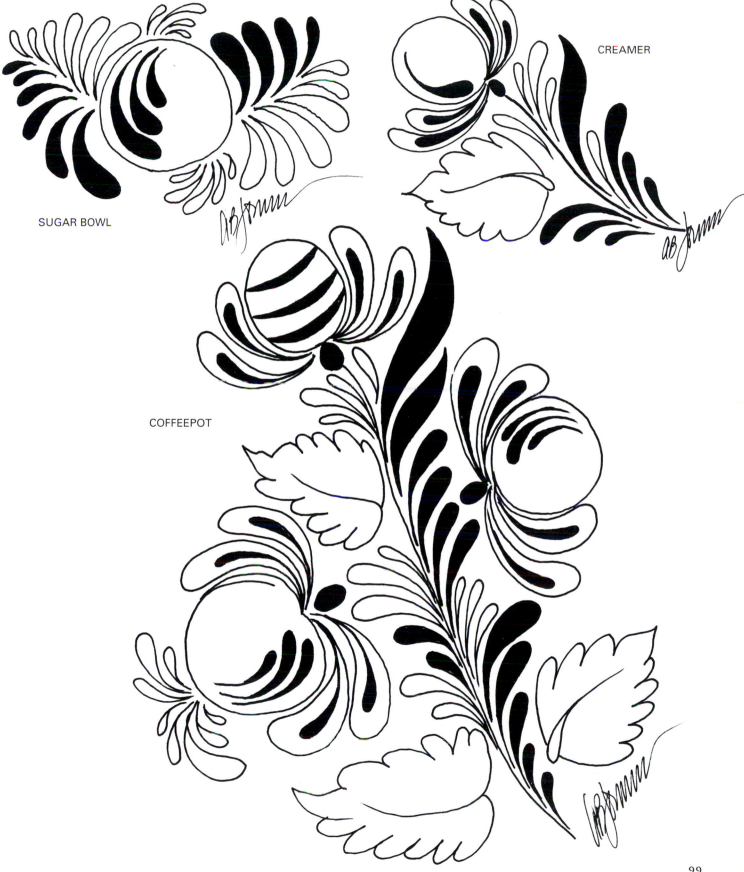

SUGAR BOWL

CREAMER

COFFEEPOT

TINSEL PAINTING

Project instructions are on pages 76–79. Use the tracing at same size. See pages 44–45 for detailed instructions on tracing and transferring patterns.

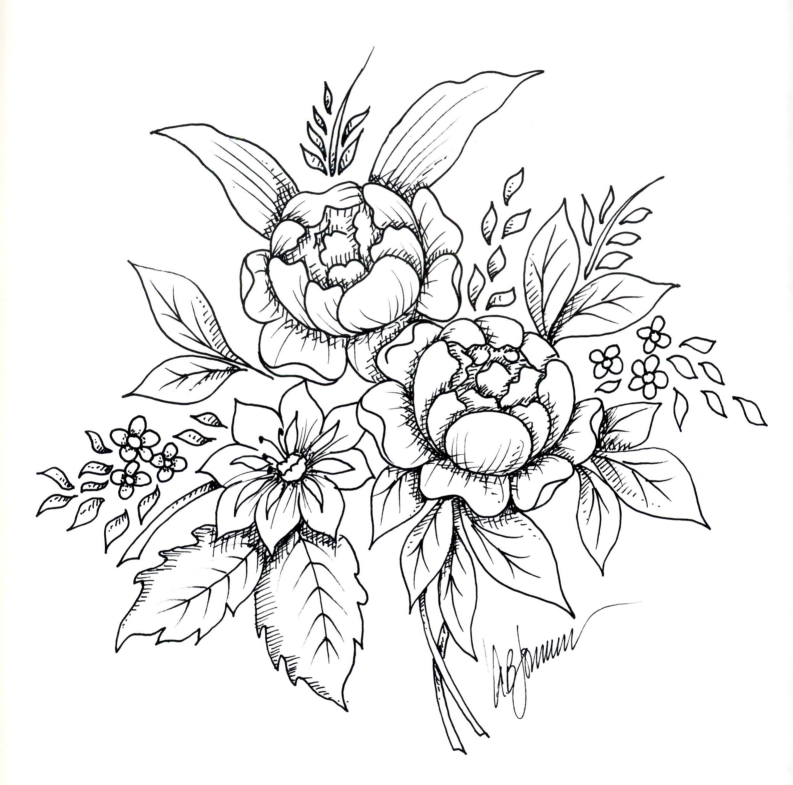

THEOREM PAINTING

Project instructions are on pages 80–83. Stencils 2, 3, and 4 are on page 102. See pages 46–47 for detailed instructions on tracing and cutting stencils.

COMPLETE STENCIL DESIGN (DO NOT TRACE)

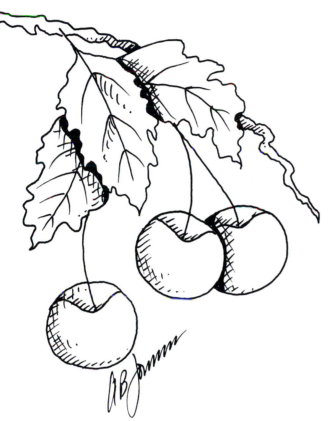

STENCIL 1

THEOREM PAINTING
See also page 101.

STENCIL 2

STENCIL 3

STENCIL 4

BRONZING

Project instructions are on pages 84–87. Stencils 1 through 5 are on pages 104–108. See pages 46–47 for detailed instructions on tracing and cutting stencils.

COMPLETE STENCIL DESIGN (DO NOT TRACE)

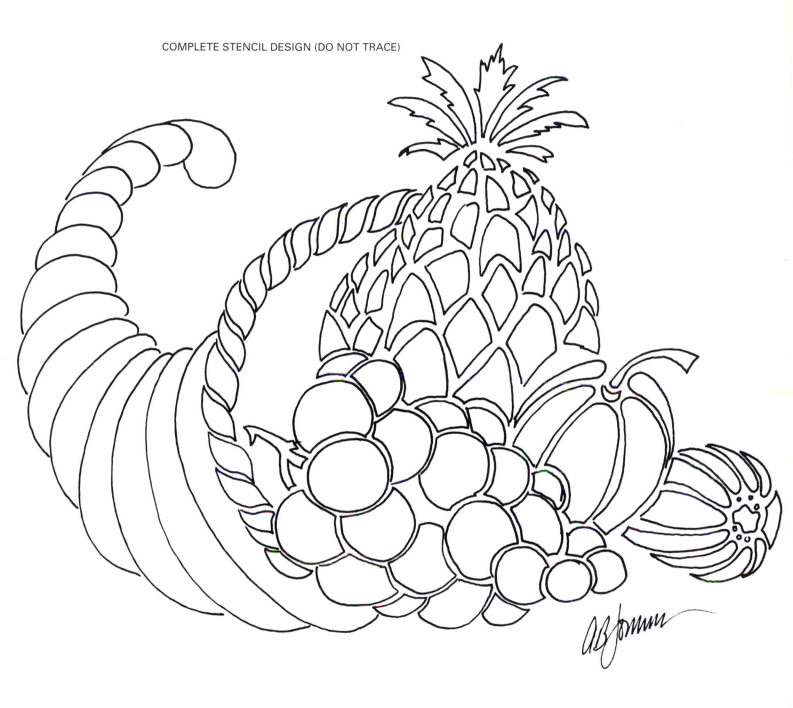

BRONZING

See also pages 103 and 106–108.

STENCIL 1

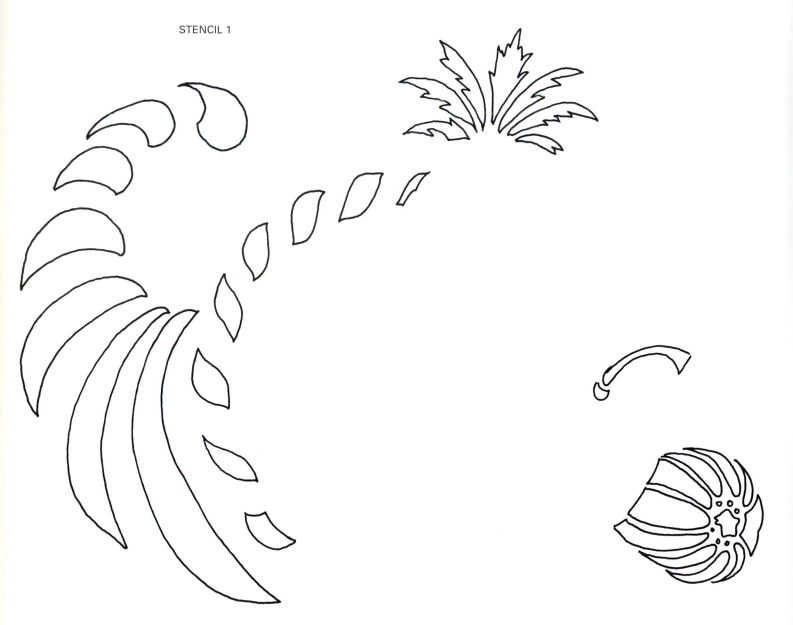

STENCIL 2

BRONZING
See also pages 103–105 and 108.

STENCIL 3

STENCIL 4

BRONZING
See also pages 103–107.

STENCIL 5

THE PETER HUNT STYLE

Project instructions are on pages 88–91. Use the tracing at same size. (Join the pattern pieces by overlapping the dashed lines.) See pages 44–45 for detailed instructions on tracing and transferring patterns.

THE PETER OMPIR STYLE

Project instructions are on pages 92–95. Use the tracing at same size. (Join the pattern pieces by overlapping the dashed lines.) See pages 44–45 for detailed instructions on tracing and transferring patterns.

Source Directory

The following is a list of sources for the supplies and projects that are used in this book. The supplies can be purchased at most art supply and craft stores nationwide. If you're interested in purchasing any of the projects, simply contact the company at the address listed below. Note that many of the project manufacturers will send catalogs of their product lines upon request.

SUPPLIES

PLAID ENTERPRISES
1649 International Court
Norcross, Georgia 30093
Acrylic paints and other decorative painting materials and supplies

SILVER BRUSH LIMITED
P.O. Box 414
Windsor, New Jersey 08561
Artist-quality brushes for decorative painting, stenciling, and faux finishing

PROJECTS

BARB WATSON'S BRUSHWORKS
P.O. Box 1467
Moreno Valley, California 92556
(909) 653-3780
http://www.barbwatson.com/
Lace-edge painting project: scallop-rim metal tray (see pages 64–67)
Bronzing project: rectangular Chippendale metal tray (see pages 84–87)

BOULDER HILL WOODWORKS
HC 61 - Box 1036
Fire Road 116
St. George, Maine 04857
(207) 372-8452
Peter Ompir project: wooden granny bucket (see pages 92–95)

CABIN CRAFTERS
1225 West 1st Street
Nevada, Iowa 50201
(800) 669-3920
Tinsel painting project: octagonal wooden box with glass lid (see pages 76–79)

COVERED BRIDGE CRAFTS
449 Amherst Street
Nashua, New Hampshire 03063
(800) 405-4464
http://www.coveredbridgecrafts.com/
Pennsylvania-Dutch project: pierced tin container with wooden lid (see pages 60–63)

CREATIVE HOME COLLECTION
PCM Studios
731 Highland Avenue N.E. - Suite D
Atlanta, Georgia 30312
(404) 222-0348
Peter Hunt project: double-lidded wooden box (see pages 88–91)

HY-JO MANUFACTURING IMPORTS CORPORATION
830 John Towers Avenue
El Cajon, California 92020
(800) 788-9969
Fraktur painting project: wooden frame (see pages 56–59)
Theorem painting project: wooden frame (see pages 80–83)

STEPH'S FOLK ART STUDIO
2435 Old Philadelphia Pike
Smoketown, Pennsylvania 17576
(717) 299-4973
http://www.stephsfolkart.com/
Early country tin painting project: round metal canister (see pages 68–71)

WAYNE'S WOODENWARE
1913 State Road 150
Neenah, Wisconsin 54956
(800) 840-1497
Colonial graining project: wooden saltbox (see pages 52–55)

Index